SAINTS, SHRINES AND PILGRIMS
Roger Rosewell

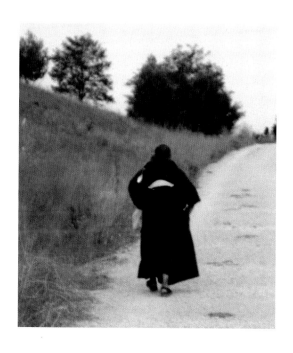

Published in Great Britain in 2017 by Bloomsbury Shire (part of Bloomsbury Publishing Plc), PO Box 883, Oxford, OX1 9PL, UK.

1385 Broadway, 5th Floor New York, NY 10018, USA.

E-mail: shireeditorial@ospreypublishing.com
www.shirebooks.co.uk

SHIRE is a trademark of Osprey Publishing, part of Bloomsbury Publishing Plc.

A CIP catalogue record for this book is available from the British Library.

Shire Library no. 797. ISBN-13: 978 0 74781 402 3

PDF e-book ISBN: 978 1 78442 198 4

epub ISBN: 978 1 78442 199 1

Roger Rosewell has asserted his right under the Copyright, Designs and Patents Act, 1988, to be identified as the author of this book.

Typeset in Garamond Pro and Gill Sans.

Printed in China through World Print Ltd.

17 18 19 20 21 10 9 8 7 6 5 4 3 2 1

COVER IMAGE
The reconstructed shrine of St Thomas de Cantilupe at Hereford.

TITLE PAGE IMAGE
A pilgrim walks the *Camino de Santiago*, the medieval route to the shrine of St James at Santiago de Compostela, Spain.

CONTENTS PAGE IMAGE
Fourteenth-century altar frontal showing the coat of arms of John Grandisson, Bishop of Exeter (1327–69), adorning the garments of SS Stephen and Lawrence. (See page 39)

ACKNOWLEDGEMENTS
I am grateful to the Dean and Chapter of the cathedrals of Canterbury, Gloucester, Hereford, Lincoln, Oxford, Rochester, St Albans, Worcester, and York. Also to the Dean and Chapter of Westminster Abbey and the numerous parish churchwardens who made me welcome wherever I went.

Thanks also to the following copyright holders:

Revd Katrina Barnes, pages 3, 56; The British Library, page 21 (upper), 55; The Trustees of the British Museum, page 21 (lower), 34 (lower); Diliff/ Wikicommons, page 20 (lower); Sam Fogg Ltd, page 42 (lower); Philip Mould Ltd, page 54; C. B. Newham, pages 6, 13, 17, 39, 43 (lower), 47 (upper right) 48, 53, 54 (lower), 67; The Master and Fellows of Corpus Christi College, Cambridge, page 34 (upper); Christopher Parkinson, page 63; Perry Lithgow Partnership, page 15 (lower); Revd. Gordon Plumb, page 46 (upper); Private Collections, pages 12, 37, 58; Revd. Jenny Replogle, page 11 (upper); Wikicommons, page 43 (upper); Kim Traynor/ Wikicommons, page 22; Trinity College, Dublin, page 10 (upper); The Walters Art Museum, Baltimore, USA, pages 11 (lower), 23; Dean & Chapter of Worcester, page 59 (lower). All other images are the Author's own.

DEDICATION
To Cameron and Lyn, generous friends.

THANKS ALSO TO
Revd Katerina Barnes; Russell Butcher (SHIRE books); Christopher Guy (Worcester Cathedral); Cameron Newham; Gethin Owen (who rescued me when my car broke down in Wales); Revd Gordon Plumb; Revd Jenny Replogle; Christine Rosewell; Joseph Spooner and Lyn Stilgoe.

Shire Publications is supporting the Woodland Trust, the UK's leading woodland conservation charity, by funding the dedication of trees.

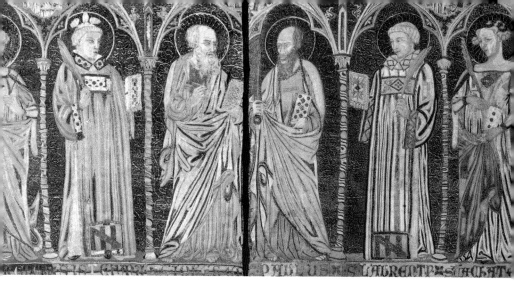

CONTENTS

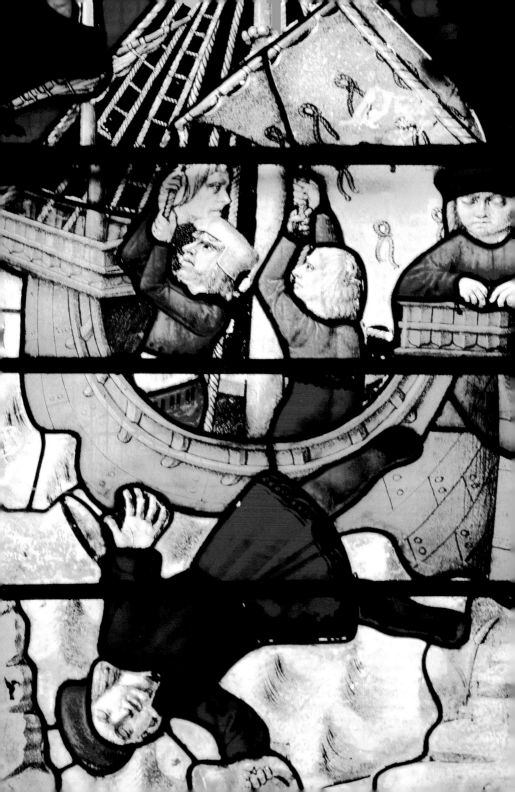

INTRODUCTION

Around 1207 a savage 'trial by combat' was fought before a huge crowd in the northern English city of York. During the fight, the loser, a man called Ralph, was blinded by his stronger opponent. Weakened by his suffering and unable to see, he was subsequently stretchered to the shrine of one of the city's most famous former archbishops, St William, in York Minster, where, after he had prayed for the saint's help, his eyesight was miraculously restored.

Such amazing stories were not uncommon in medieval Britain. Similar accounts of lost eyes being regrown by the intervention of saints were told in Canterbury and Worcester, alongside reports of cures of various afflictions ranging from leprosy to paralysis, as well as rescues from wrongful imprisonment and unjust punishment. The power of saints to help effect miracles of these magnitudes was one of the staples of Christian spirituality. The Church taught that saints like William, who sat close to God in the 'holie company of heaven', were uniquely placed to intercede with him when humans asked for divine help. Rich and poor alike believed in these intercessionary powers for almost a thousand years, shaping and defining the lives of twenty generations.

The stories of saints and their miracles were told by word of mouth, in manuscripts and through art such as stained-glass windows, wall paintings and drama. Churches were dedicated to God in their names. Kings carried their banners into battle. Every village or parish remembered them on special feast days where plays and other events re-enacted their lives and communities celebrated the protection of their powerful, if invisible, defenders and allies. Even the landscape was shaped by their stories and miracles. When young virgin girls, such as St Winefride in north Wales and St Sidwell in

Opposite:
Detail of the legend of St Nicholas and The Cup in which a drowning boy is resuscitated by the saint. Stained glass window, c. 1510–19, in the Church of All Saints, Hillesden, Buckinghamshire.

Late fifteenth-century rood-screen painting of St Apollonia holding a tooth in pincers in the Church of St Michael, Barton Turf, Norfolk.

Exeter, were beheaded by wicked suitors or jealous relatives, holy wells were said to have sprung up where their heads fell. At Whitby in Yorkshire spiral fossil ammonites found in the rocks below the cliffs were said to be snakes that had been transformed into stone by the prayers of the seventh-century saint, St Hilda, a local abbess.

Over time many saints achieved reputations for possessing special skills or areas of expertise. Favourites included St Apollonia, a Roman martyr whose teeth had been pulled out with pincers and who was consequently invoked to relieve toothache; St Nicholas of Bari (nowadays better known to many as Father Christmas) who protected children and seafarers; St Margaret of Antioch whose miraculous emergence from the belly of a dragon saw her adopted by mothers in childbirth; and St Eloi (sometimes 'Eligius', 'Eloy' or 'Loye'), a former goldsmith turned Bishop of Noyon, in northern France, whose shoeing of an uncontrollable horse possessed by the devil (he reputedly detached the leg, fixed the shoe and reattached the leg, while making the sign of the cross) saw him adopted by horse-traders and farriers.

Saints were an intrinsic part of daily life, loved and trusted by every social group. Pilgrimages to their shrines funded the

St Winefride's
Well (1512–26),
at Holywell,
Flintshire, Wales.

Stained glass in
York Minster,
c. 1414, depicting
Ralph praying
at the shrine of
St William of
York, after which
his eyesight was
miraculously
restored.

building of great cathedrals and abbeys, and created networks of roads, hostels, and chapels across Europe, forking westwards to Santiago de Compostela in north-western Spain or eastwards via Venice and by ship to Jerusalem and the Holy Land in the eastern Mediterranean.

For most of the Middle Ages, enduring beliefs in the miracles and intercessions of saints provided hope for those who sought relief from pain, sin and injustice. Saints were confidants and friends, helpers and protectors. Their lives were held up as models to follow – devout, pious, pure, immune to temptation and evil; their virtues were employed as aides and inspiration; their mercy and strength were available to all.

Life was unimaginable without them.

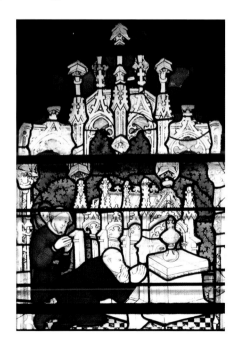

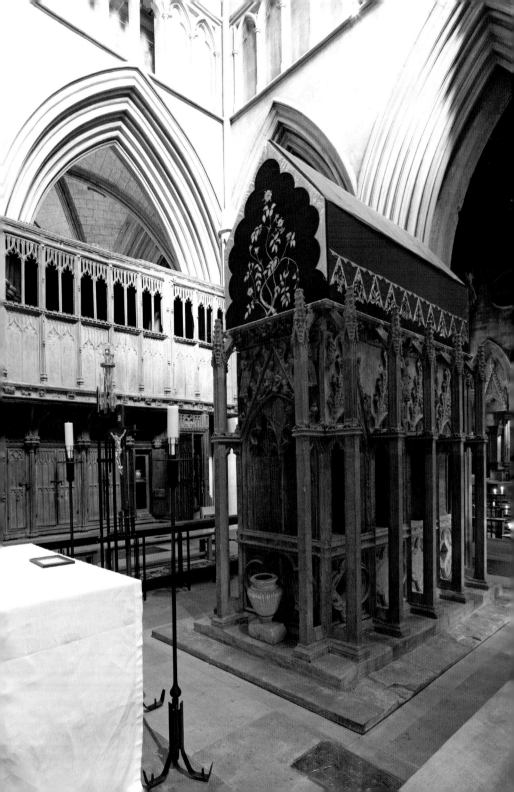

SAINTHOOD

CHRISTIAN IDEAS ABOUT sainthood flowed from the experiences of the early Church. After the death of Jesus around AD 33, apostles such as St Paul travelled widely in the Roman Empire, preaching the new religion. At first most Romans were fairly indifferent but when suspicions grew that Christianity was a disloyal sect which posed a threat to the stability of the empire, sporadic waves of persecution erupted, especially during the rules of the emperors Nero (ruled AD 54–68) and Diocletian (ruled AD 284–305).

Christians who survived these waves of terror revered those who had died for their beliefs, and built altars and churches over their graves. Many were commemorated in art holding a palm branch, representing the victory of the spirit over the flesh. The anniversaries of their martyrdoms were remembered by ceremonies which gradually evolved into a belief that, although apparently dead in body, such saints retained an active presence on earth via their relics (from the Latin *reliquiae*, meaning 'leftovers' or 'remnants'), which were either physical remains, such as bones, blood, teeth and hair, or secondary objects that had been in contact with them – their clothing, dust from their graves, water that had washed their bones, and so on. In many cases the tombs or shrines which housed the bodies were regarded as the living 'homes' of saints. Combined with prayer, such relics were seen as activating what has been called a 'holy helpline' between earth and heaven in which saints would seek to persuade an all-powerful God to answer a supplicant's prayers.

British Christianity was no exception to these ideas. As it became entrenched in England after the arrival of Augustine in AD 596, the Anglo-Saxon Church (roughly AD 600–1100) embraced concepts of sainthood with

Opposite:
Fourteenth-century reconstructed shrine of St Alban, Cathedral and Abbey Church of St Alban, Hertfordshire.

The martyrdom of
St Alban (note the
executioner's eyes
popping out of
his head in divine
punishment),
Life of St Alban,
thirteenth century,
Trinity College,
Dublin, MS E.1.40,
Fol. 38r.

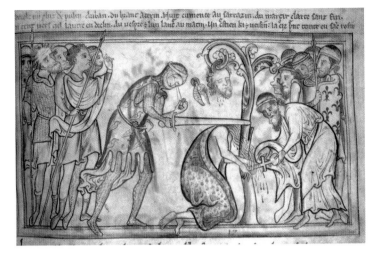

Detail of
St Edmund holding
the arrow of
his martyrdom,
stained glass
c. 1490, Church
of the Holy Trinity,
Long Melford,
Suffolk.

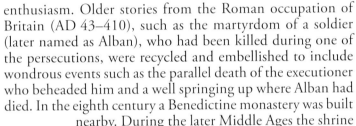

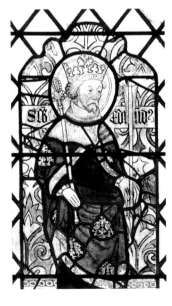

enthusiasm. Older stories from the Roman occupation of
Britain (AD 43–410), such as the martyrdom of a soldier
(later named as Alban), who had been killed during one of
the persecutions, were recycled and embellished to include
wondrous events such as the parallel death of the executioner
who beheaded him and a well springing up where Alban had
died. In the eighth century a Benedictine monastery was built
nearby. During the later Middle Ages the shrine
of St Alban attracted thousands of pilgrims and
added to the wealth and influence of the abbey.

By the time of the Norman Conquest in 1066
the English Church had spawned an impressive
roll-call of indigenous saints and established a
number of important shrines, such as that of
St Swithun (d. AD 862, Bishop of Winchester)
at Winchester, that of St Cuthbert (d. AD 687,
Bishop of Lindisfarne) in Northumberland and
that of St Edmund (a Christian king in East
Anglia executed by Danish archers in about
AD 869) at Bury in Suffolk.

An eleventh-century text, known in Old
English as the *Secgan*, listed fifty places that had
shrines and remains of Anglo-Saxon saints. Apart
from martyrs such as Alban and Edmund, the
list included pious kings and bishops (known as
'Confessors' to distinguish them from martyrs

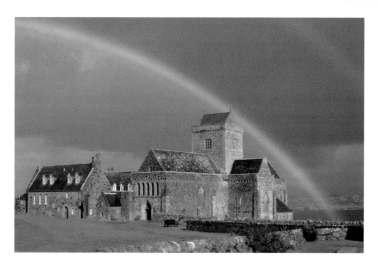

Iona Abbey, founded by St Columba in AD 563 and largely rebuilt in the twentieth century.

who had suffered a violent death), as well as princesses such as St Frideswide (d. AD 735), who founded a monastery in Oxford – the present Christ Church Cathedral is thought to have been built on the site of her Saxon church – and St Etheldreda (d. AD 679) who eventually became abbess of a double monastery at Ely (Cambridgeshire), the origin of Ely Cathedral.

Detail of the murder of Thomas Becket from an illuminated manuscript dating from c. 1260, The Carrow Hours, Walters Art Museum, USA.

Celtic Britain also had a rich heritage of saints. In south-west England areas like Cornwall revered local saints such as the fifth- and sixth-century Irish missionaries SS Ia, Piran, Sennen and Petroc, as well as figures with links to Brittany, including St Corentine, a fifth-century Breton Bishop of Quimper, and St Wite (sometimes known as St Candida), who was buried in Dorset. In Wales the principal local saint was St David (in Welsh: *Dewi Sant* d. AD 589, Bishop of Mynyw), whose best-known miracle occurred when he was preaching at the Synod of Brefi at Llanddewi Brefi (Ceredigion) and the ground on which he was standing rose up to form a small hill after those at the back of a large crowd said they could not see him.

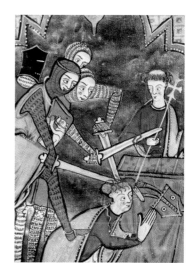

In Scotland the list again included Irish missionary monks, such as St Columba, who founded a monastery on the island of

Iona around AD 563, as well as local-born figures of whom St Kentigern (d. AD 614, Scottish missionary), popularly known as St Mungo, is probably the most famous. Glasgow Cathedral, for example, is dedicated to God in his name.

Although the Norman Conquest of 1066 challenged some of these traditions of faith and memory, especially in England, processes of assimilation and adaption gradually saw Norman bishops and abbots accept the holiness of Anglo-Saxon saints, such as St Cuthbert at Durham Cathedral, as well as championing pre-Conquest English figures such as Edward the Confessor (King of England, reigned 1042 until his death in 1066, canonised 1161). In Wales in 1120 the Norman Bishop of St David's Cathedral successfully lobbied for St David to be formally recognised as a saint by the Vatican.

Such developments paralleled separate moves towards tightening the process of declaring someone to be a saint – canonisation. Historically the conferring of sainthood was decided by local bishops in each country but in 1200 a papal bull (*bulla*), a solemn decree issued by the Pope and authenticated by an appended lead seal, changed the rules, insisting that no further canonisations could occur without the approval of the Vatican in Rome. By 1234 canonisation had become the sole prerogative of the papacy with claims of miracle-working events thoroughly investigated by specialist teams.

By far the most important canonisation after the Conquest was that of Thomas Becket, the Archbishop of Canterbury, who was murdered in the cathedral on 29 December 1170 by four knights loyal to Henry II (r. 1154–89) with whom Becket had clashed about the powers of the Church. An eye-witness description of the brutal attack, including gory details of how Thomas' brains had been scraped from his skull and scattered across the paved floor, sent shock waves across Europe.

St Edmund Rich, *The Nuremburg Chronicle* or *Liber Chronicarum* ('Book of Chronicles'), printed in Germany, 1493.

Far left:
Master John
Schorne was a
popular 'saint', but
never officially
canonised. In this
fifteenth-century
rood screen
painting in the
Church of St Helen,
Gateley, Norfolk,
he is depicted
conjuring the devil
into his boot.

Left:
Wall painting
c. 1325 depicting
the martyrdom
of Thomas of
Lancaster in
the Church
of St Peter ad
Vincula, South
Newington,
Oxfordshire.

Almost immediately stories spread that intercessions were being effected by Becket's blood which had been scooped up by monks. Within three years he had been formally consecrated. Huge numbers of people flocked to Canterbury. For much of the Middle Ages he was England's premier saint.

Other thirteenth-century figures who were canonised according to the new process included Gilbert of Sempringham, the twelfth-century founder of the only monastic order to originate in England (canonised 1202); Edmund Rich, Archbishop of Canterbury from 1233 until his death in 1240 (canonised 1246); Hugh [Bishop] of Lincoln (canonised 1220); William of Rochester, a Scottish pilgrim who was murdered by his adopted son at Rochester Cathedral (canonised 1246, sometimes also known as St William of Perth); and William [Archbishop] of York (canonised 1227).

Fewer new saints were ratified in Britain during the fourteenth and fifteenth centuries. The most important of these were Thomas de Cantilupe, a Bishop of Hereford (d. 1282, canonised 1320 after a papal investigation lasting almost thirteen years); St John of Bridlington, Prior of Bridlington Priory (d. 1379, canonised 1401); and various older historical figures such as Osmund, Bishop of Salisbury who died in 1099 (canonised 1457) and Anselm, Archbishop of Canterbury (born in about 1033, archbishop 1093–1109, canonised 1494 or 1497).

Tomb of Edward II,
c. 1330, Gloucester
Cathedral.

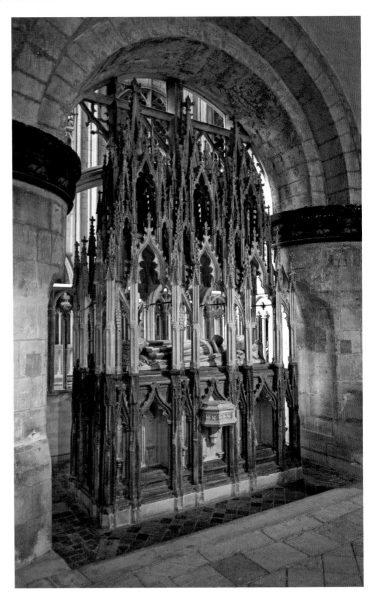

As well as the recognition of official saints there were also
'popular canonisations'; recipients included the so-called Little
Saint Hugh of Lincoln (1246–55), an English boy falsely said
to have been ritually murdered by Jews; Master John Schorne
(d. 1313), a Buckinghamshire rector credited with effecting

miraculous cures for gout and toothache; and, most famously, the deposed and probably murdered king, Henry VI (r. 1422–61 and from 1470 until his death in 1471). Like Henry, some of these 'unofficial' saints were quasi-political. For example, after the death in 1265 of Simon de Montfort, a charismatic baron who had led a rebellion against Henry III before being killed at the battle of Evesham (Worcestershire), his tomb in the nearby abbey became a semi-shrine, provoking a royal dictum which prescribed corporal punishment for anyone claiming that the rebel leader was a saint. Again, when Thomas, Earl of Leicester and Lancaster (d. 1322), was executed after leading a rebellion against Edward II supporters said that miracles occurred at his tomb at Pontefract (Yorkshire). Perhaps the most famous of these political saints was Archbishop Richard Scrope who was beheaded for high treason in 1405 for his part in the 'Northern Rising' against the Lancastrian King Henry IV (r. 1399–1413) and thereafter became the focus of a local cult in York Minster. This proved so alarming that one of the king's sons ordered barriers to be built around the tomb to deter pilgrims. The veneration of Edward II (r. 1307–27) sheds extra light on these 'unofficial cults'. Despite

Roof boss in Worcester Cathedral, *c.* 1375, featuring St Mary Magdalene (see page 16).

Wall painting, *c.* 1490, depicting St Gregory the Great, in the Church of St Gregory, Norwich, Norfolk (see page 16).

Stained glass of St Peter, c. 1420–30, in the Church of St Mary, Drayton Beauchamp, Buckinghamshire.

being hated in his lifetime, the deposed king soon developed a following after his tomb was built in Gloucester Cathedral, circa 1330. Irrespective of how badly some people had behaved during their lives, the public appetite for novelties, fresh saints and the possibility of new miracle-working shrines was insatiable.

Apart from indigenous saints, medieval worshippers also venerated a range of other figures. The most important were directly connected with Christ and the Bible, primarily St Mary, his mother, often referred to as 'Our Lady'; St John the Baptist; St Mary Magdalene, to whom Christ had appeared after his resurrection from the dead; the four Gospel writers, SS Matthew, Mark, Luke and John, and apostles mentioned in the Bible, led by SS Peter and Paul. Other popular figures included SS Ambrose, Augustine of Hippo, Jerome and Gregory who were hailed as the 'four Doctors of the Church' – a tribute to their scholarly writings. Yet more, such as the pseudo-historical figures SS Katherine, Margaret and Barbara, or SS George and Christopher, had their origins in the eastern Roman Empire based in Greek-speaking Constantinople (now Istanbul in Turkey) and crept their way into the

Rood-screen painting of St Thomas the Apostle, c. 1505, in the Church of St Mary, North Elmham, Norfolk.

devotions of the western Church via monasteries, trade and crusades in the Middle East.

The appeal of particular saints fluctuated. Some cults were relatively short-lived while others, such as that of Thomas Becket, endured for centuries. Many were essentially local or regional figures, such as St Walstan (d. 1016, a pious farmworker) in East Anglia, St Godric (d. 1171), a hermit who lived at Finchale Priory in County Durham, or St Urith (or Hieritha), an early eighth-century virgin martyr who was killed at Chittlehampton in Devon.

SHRINES

THE ACCLAMATION OF sainthood invariably saw the bodies of saints moved or translated (*translatio*) from their original burial sites to new tombs and the construction of lavish shrines.

In a few cases bodies were 'stolen' from one monastery or church and interred in another, as when the body of St Withburga, an Anglo-Saxon royal princess and nun, was snatched from Dereham Church in Norfolk AD 974 by monks from Ely Cathedral after miracles had been attributed to her. A different problem arose in the mid thirteenth century when the monks at Dorchester Abbey (Oxon) claimed to have found the body of a former bishop and missionary, St Birinus (d. AD 649). Rather than being welcomed the news triggered a bitter dispute with the monks at Winchester Cathedral, who said that they had possessed the body since the sixth century and quoted an entry in the important eighth-century *Ecclesiastical History of the English People* written by the Venerable Bede (d. AD 735), as proof of their ownership. When the Church investigated the rival claims the Dorchester monks said that Bede must have misheard what he had been told as the body in Winchester was one of their less significant former bishops, Bertinus, rather than Birinus; the former's grave having been found near a door, while the far more important Birinus had been given a grander burial below the floor near an altar. A witness who claimed to hear a heavenly voice explaining: 'It is Bertinus behind the door, but Birinus under the pavement,' seems to have tipped the balance in Dorchester's favour.

In some instances the bodies themselves were found in miraculous circumstances, as in the case of St James (the Great or Elder), whose shrine at Compostela in north-western Spain became a major pilgrimage site during the Middle Ages. The

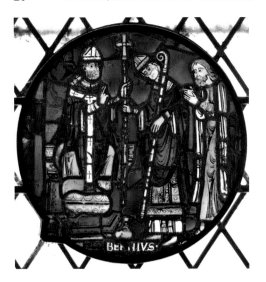

Stained glass, c. 1225, in Dorchester Abbey, Oxfordshire, showing St Birinus, holding a crozier, receiving a cross-staff from an archbishop.

connection between the saint and Spain owed everything to legend. After his relics were discovered in Galicia around AD 820 by a hermit who was said to have been led to them by a star, a shrine was built. This attracted a small following until the tenth century when kings such as Sancho I of León (r. AD 960–66) embraced St James as part of the battle against the Moorish (North African Muslim) occupation of much of Spain.

Owning the body of an important saint had a huge impact on the funding and prestige of religious institutions such as cathedrals, abbeys and local churches. St Thomas de Cantilupe's cult at Hereford, for example, funded significant building works at the cathedral. In 1290/91 income from pilgrims visiting his shrine provided sixty per cent of the fabric fund, and a report written in 1307 suggests that it may have played a key role in financing the building of the south transept, nave aisles, north porch and both main and western towers. When monks at Evesham embarked on the rebuilding of their abbey in the late eleventh century they took the relics of St Egwin (d. AD 717, an Anglo-Saxon monk and bishop)

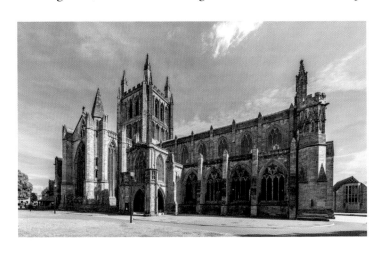

North porch of Hereford Cathedral, c. 1300.

on a fundraising tour of southern England, visiting Oxford, Winchester, London and Dover, preaching and asking for donations.

Translation ceremonies followed a remarkably familiar pattern. When coffins were opened the saint's body sometimes exuded a sweet fragrance and was often found to be incorrupt – not decayed in any way. According to Bede's twelfth-century account of the life of St Cuthbert, *Vita Sancti Cuthberti*, when St Cuthbert's coffin was opened eleven years after his death in AD 687 the monks 'found his body entire, as if he were still alive, and his joints were still flexible, as if he were not dead, but sleeping. His clothes, also, were still undecayed, and seemed to retain their original freshness and colour.'

Despite occasional objections, from at least the fourth century, translations often involved the dispersal or dissemination of a saint's relics to more than one place in order that the fragments could perform miracles for new and larger audiences. Many of these smaller disarticulated relics were housed in ornately decorated caskets known as reliquaries which were usually displayed on altars. Some were shaped to represent the saint or various parts of his or her body such as an arm, head, leg, foot or finger. Others were designed as a monstrance (Latin: *monstrare* – to show), which placed the relic on view inside a crystal cylinder. Another style of reliquary followed an architectural design, such as an ornately modelled church.

Relics were distributed in several ways. When

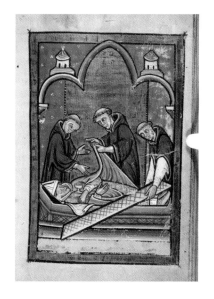

The opening of St Cuthbert's tomb in AD 698, manuscript illumination from Bede's *Life of St Cuthbert* (Durham), fourth quarter of the twelfth century, British Library, Yates Thompson MS 26, f.1v.

Swiss silver repoussé head reliquary of St Eustace, 1180–1200. The sides of the plinth are ornamented with saints standing under an arcade of trefoil-headed arches, British Museum.

Sixteenth-century woodcarving depicting St Andrew on the coat of arms of the burgh of St Andrews, St Andrews Museum (Fife).

Pershore Abbey (Worcestershire) was refounded in the tenth century it was claimed that the skull and rib bones of the Anglo-Saxon royal saint, St Edburgh, had been bought from the Abbess of Nunnaminster (St Mary's Abbey, Winchester) after the convent ran into financial troubles. For Pershore the purchase produced a good investment: about a hundred miracle cures were credited to the intercession of St Edburgh.

Usually, however, relics were dispersed as gifts. In the 1170s, for example, Henry II was given a finger bone of St Bernard (d. 1153), a leading figure in the creation of the Cistercian monastic order, by the Abbot of Clairvaux. Likewise, when the body of St Wulfstan, the last Anglo-Saxon Bishop of Worcester (d. 1095, canonised 1203), was translated to a new

shrine in the cathedral in 1218 the Abbot of St Albans was given one of his rib bones.

Two of the most important disarticulated relics of medieval Britain were the bones of the martyred apostle, St Andrew, which were possibly brought to Britain in AD 597 and subsequently taken to Fife in Scotland by Bishop Acca of Hexham in AD 732, and the hand of St James given to Reading Abbey by Henry I (b. 1068, reigned 1100–35) and his daughter, Matilda, probably around 1133.

After the X-shaped cross, associated with the manner of St Andrew's crucifixion, appeared in the sky during a battle won by the Scottish king against the English in AD 832, the 'saltire' became, and remains, the symbol of Scotland.

At Reading the hand of St James was encased in an ornate gold arm-shaped reliquary, perhaps similar to the surviving arm reliquary of St Pantaleon (a Greek physician and martyr) now in the Walters Art Museum, Baltimore, USA. According to a manuscript written in circa 1200 the relic worked its miracles by people drinking or bathing in water in which the reliquary had been immersed, the so-called 'water of St James'.

In greater churches shrines were usually built near or behind the high altar, in the latter case often accessible via a continuation of the aisles on either side of the nave leading to an ambulatory (Latin: *ambulatorium* – walking place), at the eastern end of the church. Another common location was in the north transept; examples include the shrines of St Birinus

Arm reliquary of St Pantaleon (a fourth-century Greek Christian martyr) made of gilded silver with rock crystal, semi-precious stones, glass and niello, c. 1270, Walters Art Museum, Baltimore, USA.

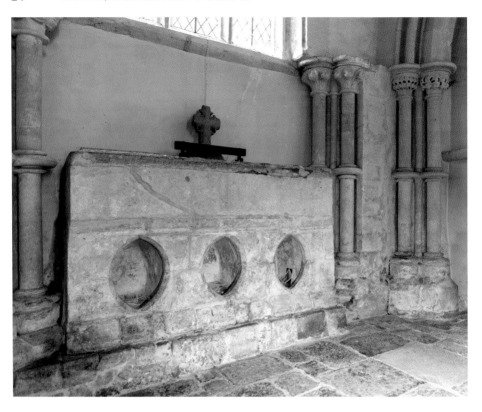

Thirteenth-century shrine of St Whit in the north transept of the Church of St Candida and Holy Cross, Whitchurch Canonicorum, Dorset.

at Dorchester, St Frideswide in Oxford and St Whit at Whitchurch Canonicorum.

The design of shrines changed over centuries. Anglo-Saxon shrines often consisted of coffin-shaped chests surmounted by gabled roofs with the bodies of the saints buried underground. During the eleventh and twelfth centuries the design evolved into a stone or marble tomb-shrine with 'port holes' running along the sides. The most famous example of these *foramina* (Latin: *foramen* – hole) shrines was probably in the crypt at Canterbury Cathedral where St Thomas Becket was buried after his murder. The monument is depicted in the thirteenth-century stained-glass windows installed in the Trinity Chapel at the eastern end of the church. They show the tomb with two holes, rather than the usual three. Pilgrims were able to insert their heads to kiss or lick the coffin and receive its curative powers. In one instance a man managed to climb into the tomb through one of the holes and lie on top of

the coffin. The same windows which show the tomb also record miracles said to have occurred in the late twelfth century.

Three examples of *foramina* tomb-shrines survive: those of St Osmund, in the Lady Chapel of Salisbury Cathedral, of St Bertram (or Bertelin), an eighth-century hermit, in the Church of the Holy Cross at Ilam (Staffordshire), and of St Wite (Latinised as St Candida) at Whitchurch Canonicorum (Dorset). The last two have three vesica-shaped apertures for pilgrims to insert their heads, hands, arms or feet.

From the twelfth century onwards shrines became more opulent. The coffin was raised up on a base and the relics housed in an elaborate super-structure which was often festooned with gold and precious stones. At Canterbury Cathedral the lower part of Becket's shrine was of stone with recesses into which pilgrims could press their limbs, the nearest contact possible to the healing body of the saint. Above this was a wooden box-like canopy or case suspended by a rope to a pulley in the roof

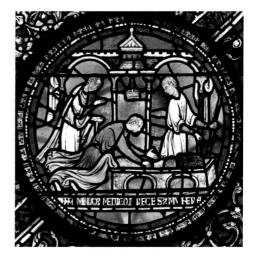

Foramina tomb of St Thomas Becket depicted in stained glass, *c.* 1213–20, Canterbury Cathedral.

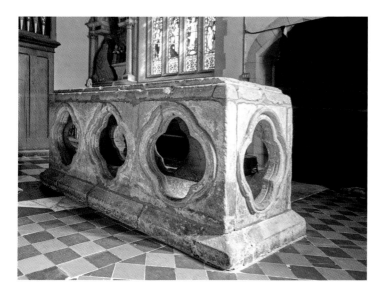

Thirteenth-century *foramina* tomb of St Bertram in the Church of the Holy Cross, Staffordshire.

Interior of St
Bertram's shrine.

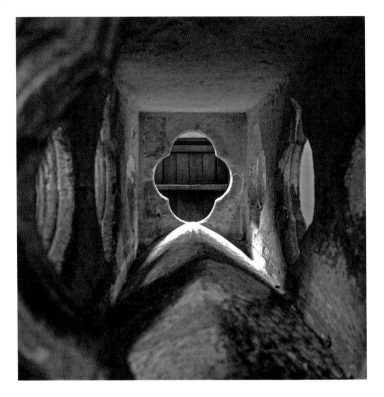

by which it could be drawn up or lowered. When it was raised
it exposed the feretory (Latin: *feretrum* – a house-shaped chest
containing relics). Tinkling silver bells were attached to the
canopy adding a musical dimension to the ceremony, very
similar to the arrangement at St Cuthbert's shrine in Durham
Cathedral. A description of the Canterbury shrine written by
a Venetian pilgrim around 1500 summed up the sight:

> Notwithstanding its great size it is all covered with plates
> of pure gold; yet the gold is scarcely seen because it is
> covered with various precious stones, as sapphires, ballasses
> [spinel, a deep blood red gemstone], diamonds, rubies,
> and emeralds and wherever the eye turns, something more
> beautiful than the rest is observed, Nor, in addition to
> these natural beauties, is the skill of art wanting; for in
> the midst of the gold are the most beautiful sculptured
> gems, both small and large, as well as cameos; and some
> cameos are of such a size that I am afraid to name it; but

everything is far surpassed by a ruby, not larger than a thumb nail, which is fixed at the right of the altar.

Nor was this the only highly decorated example. The feretory of St Erkenwald (Anglo-Saxon Bishop of London, AD 675–93) in old St Paul's Cathedral was made of silver gilt and shaped like a small church with flying buttresses on each side and covered in small statues studded with precious gems. The shrine of St Edward the Confessor in Westminster Abbey had mosaic inlaid columns and a feretory depicting six gold kings with sapphires and emeralds in their crowns.

Theft was a constant fear. In 1364 thieves stole the head shrine of St Hugh from Lincoln Cathedral and sold its gold and silver coverings for twenty marks. Although the head was recovered and the culprits caught and hanged, the incident emphasised the importance of security. At St Albans a finely carved watching loft from circa 1400 overlooks the shrine. At Peterborough Abbey (now Cathedral) the arm of St Oswald (Christian King of Northumbria, AD 634–42) was kept in a silver casket in a special chapel in the south transept and guarded by monks from a still surviving watchtower. Many shrines were protected by gates and iron railings.

Surrounding areas to the shrine were also decorated. At least at Canterbury, York, Worcester and Evesham adjacent stained-glass windows or wall paintings told episodes from the life of the saint. At Ilam (Staffordshire), the font was carved with scenes from the life of St Bertram, an eighth-century Mercian prince who became a hermit after his wife and newborn baby were devoured by wolves. Bay 1 of the

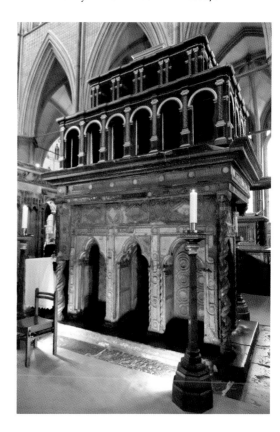

Thirteenth-century shrine of St Edward the Confessor, reconstructed during the reign of Mary I (r. 1553–58), Westminster Abbey.

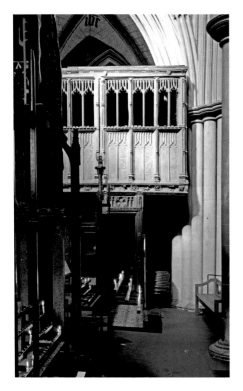

Above: Fifteenth-century watching loft, St Albans Cathedral.

Above right: Stained-glass windows at Canterbury Cathedral, c. 1213–20, depicting the miracles of St Thomas Becket.

font shows the newly married couple; others depict Bertram's wife in labour and wolves devouring the mother and baby.

Another common feature of shrines were symbolic offerings such as wax models of arms or legs which had been cured or lengths of chain representing freedom from imprisonment. At Hereford the commissioners investigating St Thomas de Cantilupe's canonisation recorded 170 ships in silver and forty-one in wax; 129 images of men or their limbs in silver and 1,424 in wax; 108 crutches; and three vehicles in wood and one in wax left by cured cripples. St William's shrine in York was also adorned with wax models of body parts, heads, hearts and legs.

Many major shrines also displayed collections of smaller relics belonging to other saints.

Visitors to Iona Abbey, off the western coast of Scotland, not only visited the tomb of St Columba; the entire island functioned as an extended shrine with a circuit of numerous satellite sites, including crosses, outlying chapels, burial

grounds, hermitages and other holy places associated with the saint and his miracles.

Although nearly all such shrines were destroyed during the Reformation, partial reconstructions survive: at Westminster Abbey (that of Edward the Confessor); Chester Cathedral (that of St Werburgh, d. AD 699, an Anglo-Saxon princess who became a nun);

St Bertram and his wife, Bay 1 of the late-twelfth-century font in the Church of the Holy Cross, Ilam, Staffordshire.

Dorchester Abbey (that of St Birinus); Hereford Cathedral (that of St Thomas de Cantilupe); and at the eponymous St Albans Abbey where the shrine of St Alban was reassembled from two thousand fragments in 1872. Parts of two shrines venerating

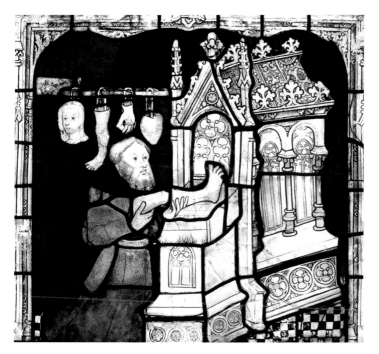

A man holds up a wax model of his leg to the shrine of St William, stained glass, c. 1414, York Minster.

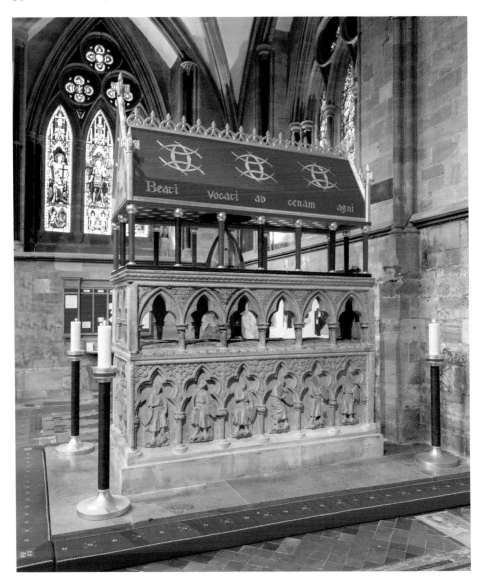

Beati vocati ad cenam agni

Shrine of
St Thomas
de Cantilupe,
c. 1287, Hereford
Cathedral.

St William of York can be seen in the Yorkshire Museum in York, the first dating to the 1330s and the second from a later rebuild dating from circa 1485. The base of St David's shrine at the Welsh cathedral that bears his name was restored in 2012. The base of St Frideswide's shrine is in the Latin chapel of Christ Church Cathedral, Oxford. The richly carved

pedestal of St Hugh's head shrine can be seen in Lincoln Cathedral. Unfortunately nothing survives of Thomas Becket's great shrine at Canterbury Cathedral. A lit candle on the pavement in the Trinity Chapel is a poignant reminder of its loss.

Fragment from the shrine of St William of York, c. 1330, Yorkshire Museum.

In the independent medieval kingdom of Scotland major shrines included that of St Duthac (an eleventh-century preacher) at Tain (Ross); that of St Ninian (fourth–fifth-century Christian missionary in southern Scotland) at Whithorn (Dumfries and Galloway); that of St Columba at Iona; that of St Kentigern, also known as St Mungo, at Glasgow Cathedral; that of St Andrew at St Andrews (Fife); and the shrine of St Margaret of Scotland at Dunfermline Abbey (Fife).

Below left: Base of St Hugh's head shrine, late thirteenth century, Lincoln Cathedral.

Below right: A candle symbolising the lost shrine of St Thomas Becket, Trinity Chapel, Canterbury Cathedral.

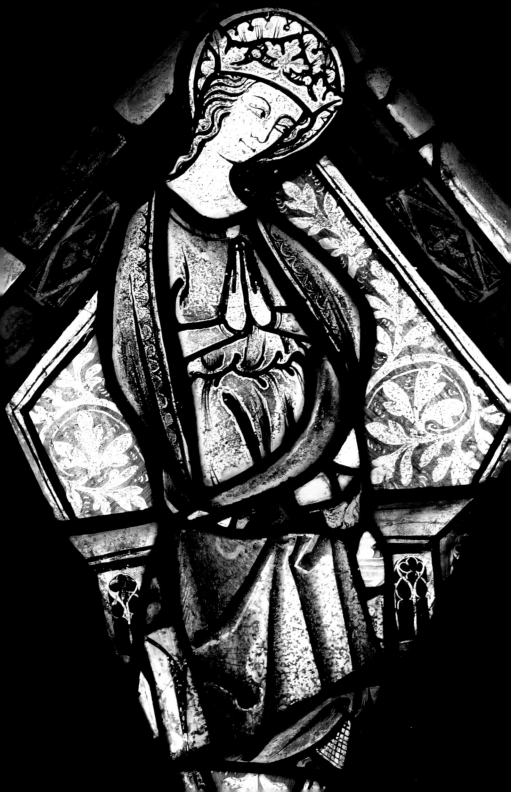

CHRIST AND THE VIRGIN MARY

Although pilgrims could visit Christ's tomb in Jerusalem and other Biblical sites in the Holy Land, relics of Christ and his mother, the Virgin Mary were extremely problematic.

According to the Bible Christ ascended to heaven forty days after his resurrection leaving nothing of his flesh or blood on earth. However, that did not stop some in the Church from endorsing phials of his blood, supposedly collected at the time of his crucifixion, as real and encouraging pilgrims to visit these 'relics'. Three such phials were venerated in England. The first was given to Henry III in 1247 by the Patriarch of Jerusalem and was carried in a crystal vase by the king from St Paul's Cathedral to Westminster Abbey, where it was deposited.

Yet, despite the pomp of its arrival, this phial never enjoyed the same fame or status as the other relics whose pedigrees were thought to be more reliable: the 'Holy Blood' at the Cistercian Abbey of St Mary at Hailes, two miles north-east of Winchcombe in Gloucestershire; the other at the collegiate church of the Bonhommes, a branch of the Augustinian Order of Friars, at Ashridge in Hertfordshire. In both cases the donor was the same man, Edmund, 2nd Earl of Cornwall (1249–1300), one of Henry III's nephews, who had acquired the phials in Germany in 1268/69.

Other prized relics included thorns from the crown of thorns worn by Christ during his crucifixion and fragments of the cross on which he had been crucified. An example of the former is in the British Museum, housed in a gold and enamel reliquary made in circa 1400–10 for Jean, Duc de Berry, a member of the French royal family.

Splinters of the cross were more plentiful but, as with phials of the Holy Blood, not all were treated equally. One of

Opposite:
The Virgin Mary as Queen of Heaven, stained glass, c. 1330–50, in the Church of St Nicholas, Stanford-on-Avon, Northamptonshire.

King Henry III carrying the relic of the Holy Blood to Westminster Abbey, drawing by Matthew Paris, Corpus Christi College, Cambridge, Corpus MS 16 (Matthew Paris) fo. 215r.

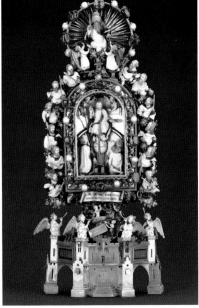

The Holy Thorn Reliquary, c. 1400–10, now in the British Museum.

the most famous was acquired by Bromholm Priory, a small Cluniac monastery near Bacton, in Norfolk around 1220, and soon attracted pilgrims. It was as long as a man's hand with two transverse pieces and was known as the Rood (a cross or crucifix) of Bromholm. Strip-cartoon-like sequences of the legendary story of the Empress Helena's 'Discovery of the True Cross' and its subsequent fate survives in stained-glass windows at Morley Church in Derbyshire, probably removed from the cloisters of nearby Dale Abbey after the Reformation, and at the parish church at Aston-under-Lyme (Greater Manchester).

Relics associated with the Virgin Mary were also cherished. She was the mother of Christ and was thought to intercede with God on behalf of penitent humans when judgement between eternal salvation and everlasting damnation was made. She was

St Helena and the True Cross, stained glass, c. 1450, in the Church of St Mary and St Barlok, Norbury, Derbyshire.

loved for her mercy and gentleness. From at least the thirteenth century her image appeared behind the high altar of every church, and more churches were dedicated to God in her name than any other saint.

Yet, despite her importance in the Christian story, no mention of her death appears in the Bible and the Church never claimed to have found her body or tomb. From the fourth century onwards so-called apocryphal Gospels (not written by one of Christ's apostles or their immediate disciples) sought to solve this mystery by claiming that when St Mary died she was carried (referred to as the Assumption) into paradise by angels where she was reunited with her son

Above left:
Modern statue
of Our Lady of
Walsingham in the
Slipper Chapel,
Walsingham,
Norfolk.

Above right:
Stained glass from
c. 1400 depicting
St Anne and the
Virgin Mary in
the Church of St
Mary the Virgin,
Thenford, North-
amptonshire.

and crowned Queen of Heaven. As a result associated relics
were highly sought-after. Chartres Cathedral in northwestern
France claimed to possess the tunic she wore during the birth
of Christ – the *Sancta Camisia* – and decorated the eastern
end of the church as if it were a reliquary to hold this precious
object. In Loretto, Italy, the *Basilica della Santa Casa* (Basilica
of the Holy House) owned what it said was the house in
Nazareth where Mary had lived and Jesus grew up and which
had been miraculously flown to the city after the expulsion of
the Crusaders from the Holy Land.

Although British churches could not rival these treasures,
there were a large number of miracle-working holy wells and
statues or images of the saint which drew visitors. The most
famous was in the so-called 'Holy House' at Walsingham
in Norfolk, built as a copy or imitation of the same house
which had been built in Loretto and where the angel Gabriel
had told Mary that God had chosen her to bear his only son
(the Annunciation). Its fame rested on a twelfth-century

statue of the Virgin and Child and a relic of her holy milk to which miracle-working powers were attributed. In the 1250s the chapel was popularised by Henry III who made several pilgrimages to the site. The shrine attracted further support during the reign of his son, Edward I (r. 1272–1307), who paid twelve visits to the site, which by the fifteenth century had become of national importance, and particularly to Henry VII (r. 1485–1509) who paid a visit in 1487 to seek the statue's help in preserving him from the 'wiles of his enemies'.

Other famous images of St Mary were at Worcester Cathedral (Our Lady of Worcester), Glastonbury Abbey (Our Lady of Glastonbury) and at the (now lost) Carmelite Friary in Doncaster (Our Lady of Doncaster). Welsh examples included Our Lady of Cardigan, a statue of the Virgin found beside the River Teifi, in south-west Wales, supposedly with a burning taper in its hand. In Scotland similar devotions were widespread even as late as the 1530s when a shrine to Our Lady of Loretto was founded at Musselburgh in East Lothian.

Images of the Virgin Mary and her life and miracles proliferated in art such as stained-glass windows, wall paintings, free-standing sculpture, manuscript illuminations and panel paintings, some of which featured stories that were never mentioned in the Bible. According to an apocryphal Gospel known as the *Protoevangelium of James*, a text probably written in the second century, she was conceived with a kiss at the Golden Gate in Jerusalem and her mother's name was Anne. In later centuries images of St Anne often showed her teaching her daughter to read. Although essentially part of wider Marian devotion, these may well have encouraged aristocratic women to educate their daughters, following Anne's example. Other functions are likely to have stressed teaching children to pray and exemplary and imitative behaviour for grandparents and family.

Scenes from the life of St Mary also appeared in altar retables, paintings or sculptures.

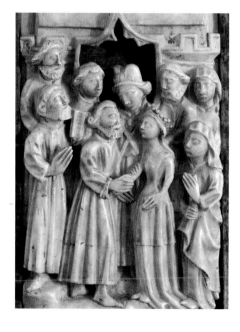

Alabaster altar panel showing the Marriage of the Virgin, dating from c. 1480, private collection.

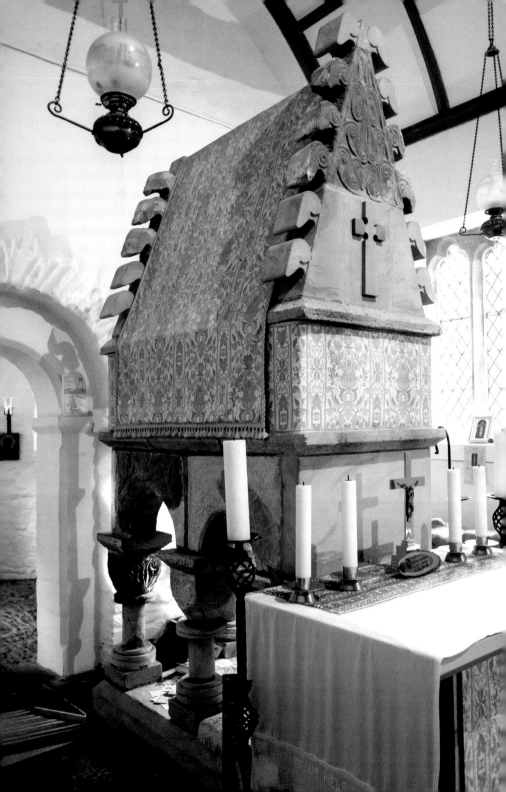

SAINTS IN DAILY LIFE

SAINTS WERE PART of everyday life: children were named after them; every parish had its own protector; every city, every craft and profession from sailors and farmers, soldiers and artists, to lawyers and merchants invoked those who might help them. Many enjoyed a pan-European following.

Pregnant women prayed before images of St Margaret of Antioch, the patron saint of childbirth. When plagues spread people asked St Roche, a French pilgrim who had been miraculously cured, to plead for their protection; travellers hoped St Christopher would defend them from sudden death on the road.

Rich and poor alike were devoted to saints. Henry IV (r. 1399–1413) and his second wife, Joan of Navarre, were buried near Becket's shrine at Canterbury as had been an earlier English hero, Edward Plantagenet, the Black Prince (d. 1376). At Westminster Abbey, four English kings were buried in the chapel of St Edward the Confessor. The upper part of a two-part seal dating from 1322 and used by the Scottish king, Robert the Bruce (r. 1306–29), is engraved with an image of St Margaret of Scotland.

Full-time members of the Church, such as bishops, priests and members of religious orders, had a particular affinity with saints and the status they enjoyed. When John Grandisson, Bishop of Exeter from 1327 to 1369, acquired an Italian tapestry altar he added his coat of arms to the garments of SS Stephen and Lawrence (the second and fifth saints on the panel), directly associating himself with these well-known 'Church' martyrs (see page 3).

The veneration of saints also thrived in local parish churches where they appeared as free-standing statues on and around altars in chapels dedicated to them, on carved

Twelfth-century shrine of St Melangell in the Church of St Melangell, Pennant Melangell, Powys.

St Roche revealing the plague-sore on his leg from which he was cured, rood-screen painting, *c.* 1520, in the Church of St Mary, North Tuddenham, Norfolk.

roof bosses, in wall and rood-screen paintings, and as figures in stained glass and textiles. Statues of saints were usually painted, clothed and adorned with gifts. At Willesden (Middlesex), a famous statue of the Virgin Mary was draped in silk and jewels. At Wimborne Minster (Dorset), the image of St Cuthberga (Anglo-Saxon princess who founded a nunnery, AD 705) was hung with 130 rings, three silver spoons and four great 'buckylls of sylver and gilt'. In 1439 Isabella Beauchamp, Countess of Warwick, left 20 lbs of gold to be made into a crown for the statue of the Virgin Mary at Caversham (Berkshire), known as 'Our Lady of Caversham'.

The remote church of St Melangell at Pennant Melangell, near Llangynog, Powys, includes the reconstructed twelfth-century shrine of St Melangell (Latin: *Monacella*, a sixth-century abbess) complemented by carvings in the fifteenth-century rood screen showing her protecting a hare fleeing from Prince Brochwel Ysgithrog and a huntsman.

Most parish churches had one or more chapels dedicated to particular saints where offerings of candles and other gifts were made to them. At Wiggenhall St Mary Magdalene, near King's Lynn, Norfolk, a fifteenth-century glazing scheme in the north aisle of the church originally included fifty images of saints in the tracery lights, based on the litanies of the *Sarum Breviary*, a medieval book which contained the daily sequence of prayers (the Office) said by priests.

Wealthy parishioners often asked to be buried below or near their favourite saints. Images of saints were sometimes carved on tombs or incised on monumental brasses. In the church in Minster Lovell (Oxfordshire) an alabaster monument with an

effigy of a knight – of either William (d. 1455) or John Lovel (d. 1465) – has figures of St Christopher, the Virgin Mary and St Margaret sculpted on the sides.

Windows were also given to churches by donors who were depicted revering their favourite saints and asking for their mercy.

Detail from a carved fifteenth-century rood-screen showing St Melangell saving a hare from a hunt.

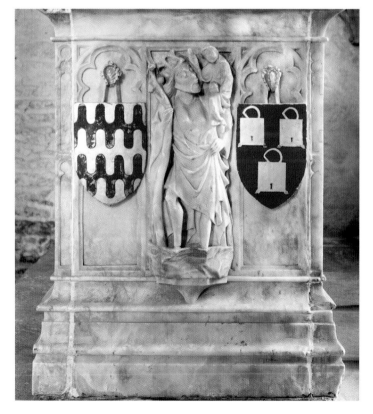

St Christopher, carved on a fifteenth-century chest tomb in the Church of St Kenelm, Minster Lovell, Oxfordshire.

At Faversham in Kent the parish church had at least four images of the Blessed Virgin Mary as well as images of SS Anne, Agnes, Anthony, Barbara, Christopher, Clement, Crispin and Crispinianus, Edmund, Erasmus, George, Giles, Gregory, James the Great, John the Baptist, John the Evangelist (two images), Katherine, Leonard, Loy, Luke, Mary Magdalene, Margaret, Michael, Nicholas, Peter and Paul, Thomas the Apostle, Thomas Becket, Ronan and Master John Schorne. All attracted bequests from parishioners and in the cases of the most popular saints like Erasmus, James, Michael, Peter and Paul, and Becket, daily masses were sung at their altars.

Similar lists could be compiled for thousands of churches before the Reformation throughout Britain. In Scotland, for example, St Mary's in Dundee had up to thirty-five altars mainly devoted to saints and the collegiate church of St Giles in Edinburgh more than fifty.

Images of saints were particularly invoked on their feast days (entries written in red letters in church calendars), when priests based their sermons on their stories and inspired devotion among local people. Before the Reformation there were between forty and fifty holy days, *festa ferianda*, when people were excused from work and expected to attend church together before enjoying a common meal. Many of these events were treated as holidays by the working poor.

Fifteenth-century stained-glass window depicting an unknown donor invoking the help of St Stephen, in the Church of St Mary the Virgin, Nettlestead, Kent. A translated Latin inscription of the scroll reads: 'O Stephen, who bore hardship, intercede for our future kingdom.'

Calendar from a French book of hours, dating from the 1470s, showing saints' days in red, courtesy of Sam Fogg Ltd.

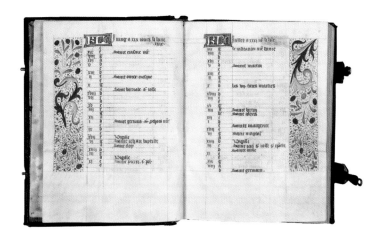

The west tower of the Church of St Urith of Chittlehampton, Devon.

Figure of St Urith holding a palm of martyrdom, c. 1500, in the Church of St Urith of Chittlehampton, Devon.

Gifts were often made to images of saints in gratitude for prayers answered or in the hope of cures, better fortune or assisting salvation. In 1531 at Beckenham (Kent), for example, Elyn Kyndyrley left a bequest for a candlestick and candles to be bought and set before the image of 'Our Lady' in the church, and four years later another parishioner, John Hickenson, gave his wife's rings to the same image.

Shrines were not just confined to cathedrals and rich monasteries. Many parish churches had shrines and holy places dedicated to saints or their relics. In Norfolk, for example, there were miracle-working images or relics of St Walstan at Bawburgh; the uncanonised Richard Caister (d. 1420, a vicar of Norwich) at Norwich St Stephen; and famous images of the Virgin Mary at Reepham, King's Lynn, Horstead and Great Yarmouth.

In Devon offerings by pilgrims at the local shrine of St Urith (Hieritha) of Chittlehampton, an eight-century Christian virgin killed by haymakers at the instigation of her heathen stepmother, helped to fund the spectacular west tower of the church. A pulpit in the church includes a figure of the saint holding a martyr's palm.

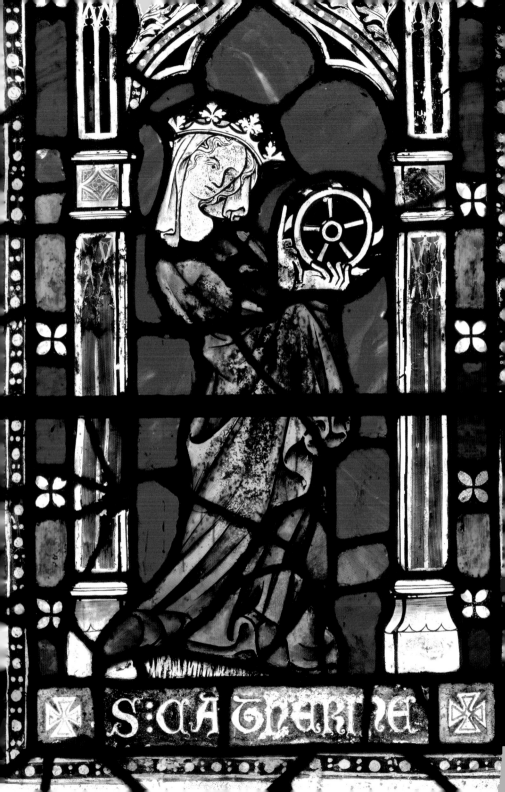

S:CATERIꞒ

LEGENDS AND MIRACLES

THE APPEAL OF saints was multifaceted. Many were said to have had miraculous lives, stories which captivated and enthralled audiences across Europe. Some, such as SS George and James fought dragons and sorcerers. Others, such as SS Katherine and Margaret, defied terrible tortures before dying for their beliefs.

Written collections of saints' lives circulated throughout Europe from at least the second century. In the late Middle Ages, the best known was the Golden Legend (*Legenda aurea* or *Legenda sanctorum*), a compilation of the life stories of approximately 200 saints (forty-one of whom were women), written by Jacobus De Voragine, a bishop of Genoa, and produced in the 1260s as a manual for preachers. It was one of the first books William Caxton (d. 1491) printed in English in 1483. There were also English collections of stories such as the *South English Legendary* written in Middle English circa 1270–85 and updated in later editions.

Most of these biographies, whether of real or pseudo-historical figures, are described as hagiographies by modern scholars and formed a distinctive type of writing, shaped by convention and tradition and expectations of what a holy life and death should look like. They were often used in sermons to teach moral lessons, to entertain and educate the young, and to help bring people closer to God.

Many were also accompanied by *Miracula*, stories of posthumous miracles performed by the saint. Between 1080 and 1220 at least seventy-five different collections of these stories were compiled, sometimes for multiple purposes as at Bury St Edmunds where the initial collection of miracles of St Edmund, written in about 1095, not only documented his achievements but also helped to enhance and protect the

Opposite: Fourteenth-century stained glass depicting St Katherine of Alexandria in the Priory Church of St Mary, Deerhurst, Gloucestershire.

A woman who is cured at the shrine of St William after swallowing a frog, stained glass, c. 1414, York Minster.

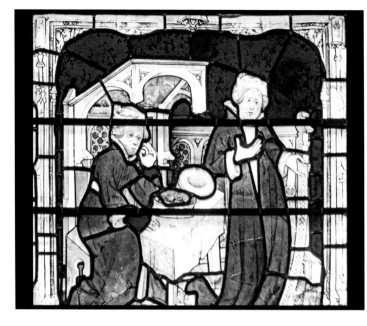

Fifteenth-century wall painting of St George trampling the dragon, Church of St Cadoc, Llangattock Lingoed, Monmouthshire, Wales.

power and prestige of the abbey at a time when it faced the double dangers of encroachments on its property by local Norman lords and a threat to its autonomy from the diocesan bishop. The *Miracula* of St Wulfstan, the last Anglo-Saxon bishop of Worcester Cathedral written circa 1235 catalogued miracles both at his actual shrine, such as the healing of an Irishman named Pippard, whose tongue had been cut out, as well as miracles enacted some distance from Worcester including the healing of a boy who was poisoned by his wicked stepmother and resuscitated from death by the hanging of a coin around his neck as a votive offering to St Wulfstan. The practice of 'vowing' pennies or candles to St Wulfstan, and other saints, was very common. One of the other stories recounted in the same *Miracula* describes the curing of a horse that had been

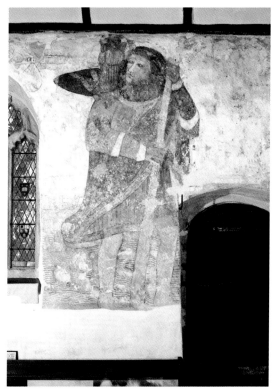

bitten by a snake, after its owner had made the sign of the cross on its head with a penny vowed to St Wulfstan.

At York Minster and Canterbury Cathedral some of the miracles attributed either to St William or St Thomas Becket were depicted in monumental stained-glass windows, visual proof of the shrine's authenticity.

Stories of pseudo-historical figures such as St George and St Katherine were also popular. The legend of St George went through several versions before settling down to the best-known account: his saving of the daughter of the king and queen of the Libyan city of Silene from a ferocious dragon. In the mid fourteenth century he was adopted as the patron saint of England and its armies.

St Katherine of Alexandria was a young Christian virgin who resisted various attempts by a Roman emperor to make her worship pagan idols. When fifty of his best philosophers tried to persuade her of her 'errors' she routed them in debate

St Margaret, stained glass, c. 1490–95, in Newarke Houses Museum, Leicester.

Fifteenth-century wall painting of St Christopher in the Church of St Breage or Breaca, Breage, Cornwall.

Fifteenth-century rood-screen painting of St Sitha in the Church of St John the Baptist, Ashton, Devon.

to the extent that they switched sides and converted to Christianity. When she was tied to a revolving wheel fitted with sharp knives she was saved from certain death by angels who destroyed 'the Katherine wheel' before it could shred her to pieces. When she was finally decapitated milk instead of blood poured from her neck. She was a symbol of learning, purity, devotion to God and heroic courage. Her image can be seen in wall paintings and in many stained-glass windows.

St Margaret of Antioch was another virgin saint persecuted for her faith. When she refused to marry Olybrius, a Roman governor and renounce Christianity, she was whipped and hung from her hair before supposedly being swallowed by a dragon. After making the sign of the cross she burst unharmed from the monster's belly; little wonder that she became the patron saint of childbirth.

St Christopher was a hugely popular figure: a giant who had supposedly carried the Christ Child across a deep and swirling river. From the twelfth-century onwards his image began to appear in almost every church as his powers were thought to be talismanic; just seeing him provided twenty-hour protection against fatigue and dying without first being shriven of sin through Confession (shrift) and receiving communion (*viaticum*) from a priest. Surviving wall paintings of the saint can usually be found opposite the south door where they could be seen easily.

Contemporary figures were also added to church calendars and prayers. One of the most interesting was St Sitha (Zita) of Lucca, in north-west Italy, a hard-working domestic servant who eventually converted her harsh employers to Christian virtues. After her death in 1272 her life was upheld as an exemplar for female service and conscientious housework; in England she seems to have enjoyed a more refined following among higher-class women. She often appears in stained glass and paintings holding a large bunch of keys.

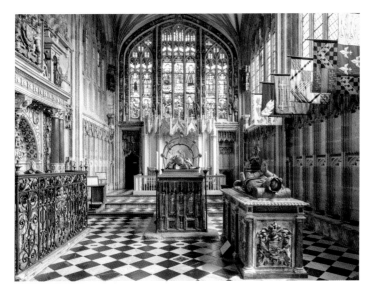

The Beauchamp Chapel (1442–62) in the Collegiate Church of St Mary, Warwick, one of the finest medieval chapels in Britain.

Stained glass depicting St John of Bridlington, Beauchamp Chapel, Collegiate Church of St Mary, Warwick.

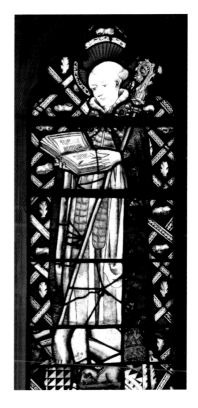

Royalty as well as peasants believed in the intercessionary powers of saints. Richard II was shown with the royal saints St Edmund and St Edward the Confessor in a portable altar painted circa 1395–99, known as the Wilton Diptych, now in the National Gallery, London. At the battle of Shrewsbury in 1403, the sixteen-year-old future Henry V was struck in the face by an arrow. Prayers to St Winefride, the seventh-century Welsh virgin martyr, were thought to have healed him. Twelve years later on the eve of the battle of Agincourt in 1415 the boy, now king, invoked the help of two Yorkshire saints, St John of Bridlington and St John of Beverley, and gave thanks for their help after his famous victory against the French. In 1408 Henry went on a pilgrimage to the shrine at Bridlington Priory. Later still, when one of the king's ablest military commanders, Richard Neville, the 13th Earl of Warwick, died, his loyalty to Henry and the Lancastrian cause saw his funerary chapel glazed with images of St Winefride and St John of Bridlington.

PILGRIMAGES

PILGRIMAGES TO SHRINES and sacred places were one of the great experiences of the medieval Christian world and began as early as the second century. People went on such journeys for lots of reasons: to seek cures; as penances; to earn indulgences; for spiritual comfort; as proxies for others; and sometimes to escape the monotony and unhappiness of village life and family. Religious tourism could be the experience of a lifetime.

Based on contemporary records, it has been estimated that around 100,000 pilgrims a year visited Canterbury annually between 1198 and 1207 and around 180,000 in 1219.

Hopes of cures for assorted illnesses and injuries drew the deaf and blind, the crippled and the maimed to every major shrine.

In the first ten years after Becket's death 703 miracles were recorded, mostly involving healing, the driving out of demons, or the finding of lost items. At St William's shrine in York Minster, wooden panels listed over a thousand miracles that had been documented at the tomb. Stained-glass windows made to complement the shrine in 1414/15 show the curing of a blind woman and a pilgrim holding a wax model of a healed leg up to the tomb, probably as a votive offering, a gift of thanks that symbolised the miracle. After the monks at Dorchester Abbey had 'discovered' the body of St Birinus in the mid thirteenth century, a spate of miracles was said to have occurred, including the curing of a leper, the restoration of life to a dead man and even someone learning to speak French in three days.

Many of these miracle-working shrines seem to have had 'limited lives'. At Hereford, for example, 160 miracles were recorded in 1287; thirty-four in 1288; nine in 1300; one

Opposite:
Cripple carried
to the holy well
of St Winefride,
carved capital,
Holywell,
Flintshire.

Reconstructed
fourteenth-
century shrine
of St Birinus in
Dorchester Abbey,
Oxfordshire.

in 1312; and thereafter apparently none. Contemporary explanations veered from saints only being given a certain number of divine favours from God which were eventually exhausted or saints wanting to be at peace and expecting the 'baton' of favours to be assumed by the more recently canonised.

As a result old saints were supplanted by new saints and shrines which initially attracted only local pilgrims drew visitors from further afield whose own shrines had seemingly 'dried up'.

One of the last new quasi-saints of the Middle Ages was Henry VI who was probably murdered in 1471 on the instructions of his Yorkist enemy Edward IV. After the king's death some people began to regard him as a saint, even though he had not been canonised (and never was). By 1473 prayers were being said before his statue on a stone screen at York Minster. In 1479 King Edward had the statue removed and tried to stop pilgrims from swarming to Chertsey Abbey where Henry was buried. In 1484, however, his remains were reburied in St George's Chapel at Windsor and soon became a national shrine drawing visitors from Wales, Manchester and even Calais. A manuscript written between 1471 and 1495 listed 174 miracles performed by him at or beyond the shrine,

including bringing back to life victims of the plague or seemingly dead children.

Another major reason for pilgrimages was as penance for sins. In the second quarter of the fourteenth century, for example, a man convicted of adultery in Rochester (Kent) was sentenced to make pilgrimages to Canterbury, Bury St Edmunds, Hereford and Walsingham. A more serious case in the same diocese saw another adulterer ordered to visit Santiago de Compostela.

A third motivation was to earn indulgences – the remission or reduction of the time of punishment for sins that a person had to spend in penance or purgatory, the latter being a place where people were 'purged' or purified of their sins after death before being allowed to enter heaven. The Church often granted such indulgences to penitents who visited a saint's shrine on their feast day. These indulgences could range from days to years. Plenary indulgences remitted all temporal punishments. The granting of indulgences were often linked to fundraising efforts by the Church and provoked strong criticism from reformers.

Most pilgrimages were made in the autumn or spring avoiding harvest time and were within a forty-mile radius of someone's home: a distance of approximately two days' walking. Some people made the arduous journeys to

Henry VI wearing ermine robes, late fifteenth century rood-screen painting, Church of St Michael and All Angels, Barton Turf, Norfolk.

Medieval
pilgrim badge of
St Thomas Becket,
Getty images.

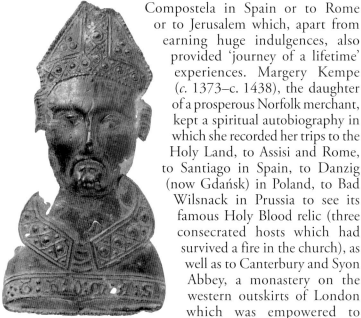

Stained glass
from c. 1450 of
St James with
a cockle shell
badge on his hat
in the Church
of St John the
Baptist, Burford,
Oxfordshire.

Compostela in Spain or to Rome or to Jerusalem which, apart from earning huge indulgences, also provided 'journey of a lifetime' experiences. Margery Kempe (c. 1373–c. 1438), the daughter of a prosperous Norfolk merchant, kept a spiritual autobiography in which she recorded her trips to the Holy Land, to Assisi and Rome, to Santiago in Spain, to Danzig (now Gdańsk) in Poland, to Bad Wilsnack in Prussia to see its famous Holy Blood relic (three consecrated hosts which had survived a fire in the church), as well as to Canterbury and Syon Abbey, a monastery on the western outskirts of London which was empowered to grant plenary remissions – 'The Pardon of Syon' – to pilgrims who visited its shrine to St Bridget of Sweden on specified dates.

Long-distance pilgrimages were major undertakings. People generally needed the permission of priests to make such journeys and many wrote their wills before doing so. Some rich people travelled in style. When Sir Andrew Luttrell and his wife went to Santiago in 1361 their party had twenty-four members and twenty-four horses. Inns and hostels were common along the main routes. A number of monasteries in Norfolk, such as Castle Acre Priory, may have offered accommodation to pilgrims travelling to Walsingham.

When pilgrims arrived at shrine sites fast-food sellers and tinkers offering votive candles and 'pilgrim badges' did a roaring trade. Pilgrim

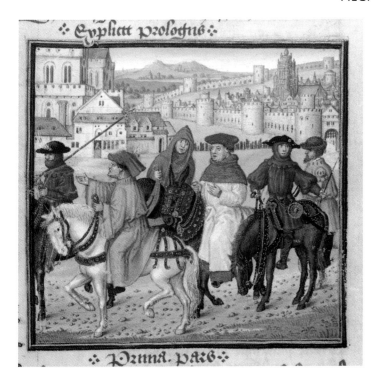

Miniature of pilgrims leaving Canterbury from John Lydgate's *Siege of Thebes*, c. 1457–60, British Library, Royal MS 18 DII.

badges were produced in vast numbers, starting shortly after the canonisation of St Thomas Becket. In the thirteenth century the most popular type were small ampulla-like containers that could be filled with holy water from a shrine and taken home by the pilgrim. Later souvenirs included tin or lead alloy badges depicting scenes such as the martyrdom of Becket (in Canterbury) or the Virgin and child in a house (in Walsingham). Pilgrims to St James' shrine in Compostela returned with cockle shell-shaped badges. St James himself was often depicted as a pilgrim wearing a wide-brimmed hat and a cockle shell badge, and carrying a purse (scip) and staff (bourdon). Pilgrims frequently pinned the badges to their hats or cloaks or wore them round their necks. Badges could even be sown into the pages of prayer books. Many were touched against the saint's shrine in order that they might imbibe some of its powers.

Pilgrims travelled along well-known routes, often in groups for safety and self-protection. Visitors to Canterbury from the west used a track from Winchester across the Sussex

Downs and the Kentish Weald known today as 'The Pilgrims' Way'. For others London was the starting point. The fictional characters immortalised by the poet Geoffrey Chaucer in *The Canterbury Tales*, written in the late fourteenth century, began their journey from Southwark in London; a plaque in Tallboy Yard, Borough High Street, marks the site of the Tabard Inn where they stayed.

The route to Walsingham in Norfolk was equally well defined. From London visitors travelled via Waltham Abbey, Newmarket, Brandon, Swaffham, Castle Acre Priory and East Barsham. From the north pilgrims crossed the River Wash near Long Sutton and came through King's Lynn (then called Bishop's Lynn).

Travellers to Santiago de Compostela from England often went by ship from ports such as Plymouth and Southampton to La Coruña on the Galician coast. The voyage took about four days. Overland routes took much longer. After descending through France, pilgrims joined the *Camino de Santiago* or 'The Way of St James', across the mountains and plains of northern Spain. The route was dotted with hostels and chapels, and cemeteries for those who died on the journey. Some churches, such as that at Villafranca del Bierzo, had 'pardon doors' where people who were too ill to complete the

Pilgrims crossing fields from Castrojeriz to Boadilla del Camino.

Stone steps worn
down by pilgrims
visiting the shrine
of St William
at Rochester
Cathedral, Kent.

journey to Compostela might receive the same blessings and indulgences as they could have gained by visiting the shrine itself. A twelfth-century book known as the *Codex Calixtinus* provided practical information for pilgrims, warning about dirty drinking water, dangerous wolves and gangs of bandits who roamed the forests, as well as recommending holy sites to see and suggesting prayers to say and songs to sing for protection along the way.

When pilgrims arrived at important shrines they entered the church through designated entrances and followed prescribed routes led by guides who explained the treasures on show.

It was an emotional, sensual and physical experience captured by the Dutch humanist, Desiderius Erasmus (1466–1536) when he visited Canterbury Cathedral around 1513 and marvelled at 'the majesty with which the church rises into the sky, so as to strike awe even at a distant approach; the vast towers, saluting from far the advancing traveller; the sound of bells, sounding far and wide through the surrounding country'.

Pilgrims to Becket's shrine were shown the spot where he had been murdered and the crypt where he had originally been buried before entering the Trinity Chapel at the eastern end of the church with its beautifully carved marble columns, inlaid floors, glowing stained-glass windows and painted ceiling of kings and bishops deferring to the splendid shrine below. It was choreographed theatre that made an enormous

Canterbury
Cathedral.

visual and spiritual impact, overwhelming in its magnificence, humbling in its power and bonding pilgrim and saint together in a never-to-be-forgotten spiritual consecration.

Monetary offerings were expected. The vast majority of donations were single pennies or farthings (a quarter of a penny), many of which were dedicated to the saint before the pilgrim left home. Pilgrims to Ely Cathedral were ushered past wall paintings of benefactors. At Canterbury collection boxes proliferated. At St George's Chapel, Windsor, a remarkable iron box with the letter H for Henry, made to receive offerings at Henry VI's tomb, survives in the south aisle of the choir.

Some pilgrims made extremely generous offerings. When the Norfolk landowner Robert Fitz-Walter and his wife were captured by bandits in southern France in 1105 on the return leg of a pilgrimage to Rome they prayed to St Faith, the patron saint of prisoners, who appeared to them in a vision and loosened their fetters. In the aftermath of their escape they visited her principal shrine at Conques and promised to found a monastery in her honour when they returned to England. Parts of that building still survive in a private house at Horsham St Faith three miles north of Norwich.

Fifteenth-century wall painting in Horsham St Faith Priory, Norfolk, depicting the arrival of monks and the building of the priory.

Whether they were curative, spiritual or adventurous, such visits were invariably transformative. When Robert Sutton died in the fifteenth century he was buried in Worcester Cathedral alongside the staff he had carried and the St James cockle shell badge he had worn during his pilgrimage to Spain. Walking with saints had been the most important and memorable event in his life, and would aid him again on his next journey towards the sacred.

Grave of a Worcester pilgrim, c. 1490, discovered in 1986 during excavations at the base of the south-east tower of the cathedral. The remains of his leather boots and his staff and badge were still in the grave.

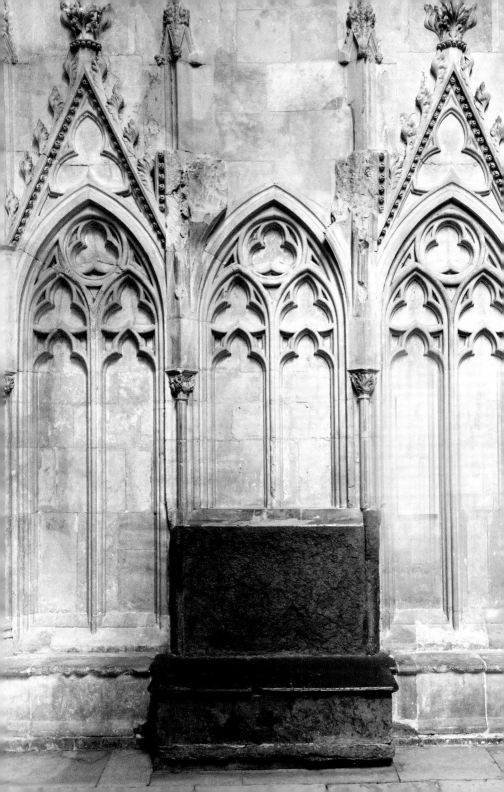

REFORMATION

In January 1510 the young Henry VIII went on a pilgrimage to the Holy House at Walsingham, just as his father and previous kings had done. Thirty years later he presided over the shrine's destruction and all that it represented.

The speed of the great religious reformations of the mid sixteenth century demolished not just buildings; it also suppressed the belief in saints and their powers which had defined English Christianity from its earliest days.

In 1534 Henry declared himself supreme head of the English church. By 1535 criticism of traditional Catholic devotional practices was becoming increasingly strident and although the appeal of Walsingham remained strong, with an estimated 62,000 pilgrims visiting the shrine in 1534, devotion to shrine saints elsewhere was shrinking. According to the shrine accounts of Lincoln Cathedral, for example, offerings had fallen from a peak of £67 3s 6d in 1367 to about £5 a year between 1490 and 1530.

In 1538 the king reversed three centuries of history and denounced Thomas Becket as a treacherous rebel not a saint. The famous shrine in Canterbury Cathedral was smashed by soldiers and churches were ordered to erase the disgraced archbishop's name from books and destroy any images of him.

At the same time, and for the next several years, hundreds of monasteries were dissolved, their wealth seized by the Crown and their so-called miracle-working shrines mocked and wrecked. The shrine of St Edmund at Bury was razed to the ground. The Holy Blood relic at Hailes was accused of being nothing more than duck's blood or a coloured gum; the miracle-working statue of Our Lady of Worcester and a statue of the Welsh saint, Derfel Gadarn (sixth-century Celtic warrior and monk) at Llandderfel (Gwynedd), were taken to London and publicly burned.

Opposite:
The base of the shrine of Little St Hugh, dating from the late thirteenth century, Lincoln Cathedral.

Head of a stag reputedly once positioned at the feet of the wooden effigy of St Derfel, church of St Derfel, Llandderfel, Gwynedd.

At Chichester Cathedral (West Sussex), Thomas Cromwell (d. 1540), the king's chief minister and a leading figure in the dissolution of the monasteries, paid two men £40 to perform the following task:

… with all convenient diligence to repair unto the said cathedral church, and to take away the shrine and bones of that bishop called Saint Richard, with all ornaments to the said shrine belonging, and all other the reliques and reliquaries, the silver, the gold, and all the jewels belonging to said shrine, and that not only shall you see them to be safely and surely conveyed unto our Tower of London there to be bestowed and placed at your arrival, but also ye shall see both the place where the shrine was kept, destroyed even to the ground and all such other images of the said church, where about any notable superstition is used, to be carried and conveyed away, so that our subjects shall by them in no ways be deceived hereafter.

Attacks on the Catholic Church and its leaders intensified as Protestant reformers denounced the doctrines of purgatory and indulgences. Pilgrimages were discouraged and ideas about saints and their relics condemned as superstitious idolatry. A set of injunctions issued in 1538 ordered people 'not to repose their trust … in … works devised by men's phantasies [sic] … as in wandering to pilgrimages, offering of money or candles … to images or relics, or kissing or licking the same'.

When Henry subsequently discovered that not every shrine had been destroyed he reacted furiously, telling bishops that despite his good intent some 'shrines, coverings of shrines, and monuments of those things do yet remain to allure our subjects to their former hypocrisy and superstition' and insisting that these be immediately removed, and that priests should be told to ensure the same happened in parish churches.

Those who resisted and who tried to cling onto their traditional beliefs were cowed and sometimes killed.

When John Forest, a Franciscan friar and confidant of Queen Catherine of Aragon, was burned alive in 1538 for denying the supremacy of King Henry VIII as head of the Church, the byre included the wooden statue of St Derfel mentioned earlier, a mocking pun on a legend which said that the effigy would one day burn down a forest.

Such attacks continued under the reign of Henry's successor, Edward VI (b. 1537, r. 1547–53), when the clergy was instructed to 'take way, utterly extinct and destroy all shrines … pictures, paintings, and all other monuments of feigned miracles, pilgrimages, idolatry or superstition so that there remain no memory of the same in wall, [or] glass'. Bonfires were made of statues, reliquaries were melted, wall paintings smothered in whitewash and stained-glass windows dismantled. The carved and painted niches which once held figures of saints were emptied. Churches were stripped of their traditional colour and wonder.

Within a few years most of England's artistic and devotional

Painted stone figure of St Margaret, c. 1430–1530, in the Church of St Andrew, Fingringhoe, Essex.

Edward VI, Circle
of William Scrots
(fl. 1537–1554)
– courtesy of
Philip Mould Ltd.

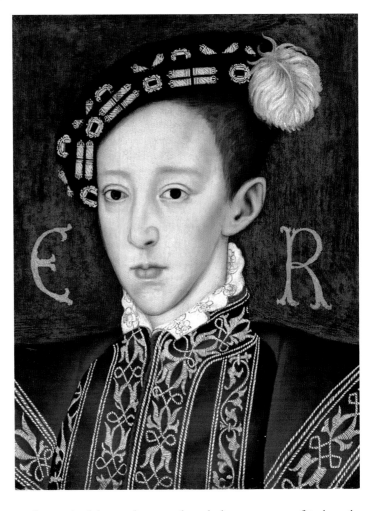

tradition had been destroyed and the memory of it largely suppressed. A so-called Counter-Reformation under the reign of Mary I saw the partial reconstruction of Edward the Confessor's shrine in Westminster Abbey but overall her efforts were too short-lived to reverse the losses.

In Scotland the Reformation followed slightly later than in England, taking place between 1557 and 1567, but was just as destructive. In 1559 the interior of St Andrew's Cathedral, including the shrine of St Andrew and its half-ton reliquary, was destroyed by reformers led by John Knox (1513–72), a fervent Presbyterian. In Edinburgh the reliquary arm of St

Giles with its diamond finger ring (acquired in 1454) was sold to some local goldsmiths.

But despite the ferocity of the reforms not every trace of saints was abolished. The new Church of England continued to remember and honour the holy and pious but in different ways from before. The Catholic Church continued to cherish those who had been outlawed, and sites such as St Winefred's Well in north Wales continue to attract modern pilgrims. St George remained the patron saint of England (just – for Edward VI thought his dragon-slaying feats were suspicious nonsense) and his emblem of a red cross

Union flag.

on a white background was counterchanged with the white saltire of St Andrew on a blue background after the regal union in 1606 to create a new Union flag, and again in a later design of 1801 incorporating Ireland. St David has remained the national saint of Wales.

And although the relationship between Christians and saints has evolved and changed over the centuries, the search for spiritual truths, for comfort in adversity and closeness to God, for friendship and mercy, for hope and justice has never wavered. And probably never will.

Modern statue of St Winefride, St Winefride's Well, 1512–26, Holywell, Flintshire, Wales.

GLOSSARY OF WELL-KNOWN SAINTS

Many images of saints contained particular symbols or attributes which enabled viewers to identify them. For example, the apostle St Peter was nearly always depicted holding a large key, reflecting the story of Christ giving him 'the keys of the kingdom' (see Matthew 16:19, in the Bible).

St Agatha: Third-century virgin martyr. Often depicted with bell-shaped severed breast, the symbol of her execution.

St Agnes: Third/fourth-century virgin martyr, killed by a dagger. Often depicted in art with a lamb, as the Latin word for 'lamb', *agnus*, sounds like her name. Her relics are conserved beneath the high altar in the church of Sant'Agnese fuori le mura ('Saint Agnes Outside the Walls') in Rome.

St Alban: Third/fourth-century proto-martyr of England. Reconstructed shrine at St Albans Cathedral, formerly a Benedictine abbey, in Hertfordshire.

St Ambrose: Fourth-century bishop of Milan; one of the 'Four Doctors of the Church'.

St Amphibalus: Third/fourth-century priest, said to have been hidden by St Alban from Roman persecutors. His reconstructed shrine survives in St Albans cathedral.

St Andrew: Apostle and brother of St Peter, said to have been crucified on an X- shaped cross. Patron saint of Scotland.

St Anne: Pseudo-historical mother of the Virgin Mary. Often depicted teaching her daughter to read.

St Anthony of Egypt: Fourth-century desert hermit. Usually depicted with a pig: his only companion in the wilderness. Often invoked for curing livestock.

St Apollonia: Third-century virgin martyr. Always depicted holding a tooth in pincers representing the tortures she suffered. Invoked against toothache.

Apostles: According to the Gospel of St Matthew, the twelve apostles were: SS Peter; Andrew; James (son of Zebedee, and known as the Great or Elder); John; Philip; Bartholomew; Thomas; Matthew; James (son of Alphaeus

and known as the Less or Younger); Thaddeus; Simon; and Judas Iscariot (later replaced by St Matthias).

Their attributes in art are: keys (Peter); saltire (Andrew); pilgrim's hat, cockle shell (James the Great); a book, a serpent in a chalice, the cauldron in which he was boiled, the eagle which brought him a pen when he was exiled on the Isle of Patmos (John); basket of loaves (Philip); knife with which he was flayed (Bartholomew); architect's square, saw, spear of his martyrdom (Thomas); boat, club (Thaddeus); axe and quill pot (Matthew); fuller's club, which looks like a hockey stick (James the Less); fish, oar, axe, saw (Simon); axe (Matthias); purse of silver (Judas Iscariot).

St Augustine: Fifth-century Bishop of Hippo Regius, (modern-day Annaba, Algeria); one of the 'Four Doctors of the Church'.

St Barbara: Pseudo-historical virgin martyr whose father locked her in a tower, her attribute in art. Her father was struck by lightning after beheading her. Patron saint of builders.

St Bertram: Anglo-Saxon prince who became a hermit after wolves had eaten his wife and baby. His thirteenth-century shrine in Ilam Church (Derbyshire) was a local pilgrimage site.

St Birgitta of Sweden: Founder of Bridgettine Order of Nuns (d. 1373).

St Birinus: Anglo-Saxon missionary and bishop. Reconstructed shrine at Dorchester Abbey (Oxfordshire).

St Blaise: Fourth-century Armenian Christian bishop and martyr; skinned with a wool comb. Patron saint of wool combers. Fourteenth-century wall painting at Kingston-upon-Thames, Surrey.

St Catherine of Alexandria: *see* **St Katherine**.

St Cecilia (Cecily): Third-century virgin martyr. Usually depicted with two wreaths (or chapelets) of flowers on her head,

Rood-screen painting of St Cecilia, *c.* 1505, in the Church of St Mary, North Elmham, Norfolk.

symbolising a gift by angels. Her association with music does not appear in art until the fifteenth century.

St Chad: Anglo-Saxon bishop of the Mercians, an Anglo-Saxon kingdom in the English Midlands. His shrine at Lichfield Cathedral (Staffordshire) had two *foci*: his tomb, in the apse, directly behind the high altar of the cathedral; and his skull, kept in a special Head Chapel above the south aisle.

St Christopher: Talismanic saint. Often shown in wall paintings, for example, in Westminster Abbey, and in stained glass. Good statue survives at Norton Priory (Cheshire).

St Clare: Friend of St Francis of Assisi; founder of the Order of Poor Clares (d. 1253).

St Clement: Pope and martyr (d. *c.* AD 99). According to tradition, Clement was imprisoned under the Emperor Trajan and executed by being tied to an anchor and thrown into the sea. Patron saint of mariners. Often depicted carrying an anchor. Wall paintings featuring St Clement include one at South Leigh (Oxfordshire).

St Columba: Sixth-century Irish abbot and missionary responsible for introducing Christianity to Scotland. His shrine was on the Isle of Iona.

SS Crispin and Crispinianus: Third-century Christian martyrs. Patron saints of cobblers, curriers, tanners.

St Cuthberga: Anglo-Saxon princess and first Abbess of Wimborne Minster (Dorset).

St Cuthbert: Anglo-Saxon Prior and Bishop of Lindisfarne (Northumberland) (d. AD 687). His shrine was at Durham Cathedral. Windows depicting his life survive at York Minster.

St Cuthman: Eighth-century Anglo-Saxon hermit. According to legend his mother was paralysed and he cared for her by building a one-wheeled cart or wheelbarrow (with a rope from the handles looped over his shoulders to take part of the weight) in which he moved her around with him. When the rope eventually broke he improvised a new one from willow stems saying that when that too broke he would to stop and build a church. The withy rope broke at Steyning in East Sussex. He is depicted in a choir seat carving at Ripon Cathedral (Yorkshire).

St David: Patron saint of Wales. Parts of his shrine survive at St David's Cathedral, Pembrokeshire.

St Derfel Gadarn: Sixth-century Welsh saint with a shrine at Llandderfel (Gwynedd).

St Dorothea (Dorothy) of Caesarea: Fourth-century virgin martyr. Her attribute is a spray or bouquet of roses and fruit symbolising a story from her martyrdom when a scribe mocked her beliefs by asking her to send a basket of fruit after her death. When a child subsequently appeared with such a basket the scribe converted to Christianity and was himself later executed.

St Dunstan: Anglo-Saxon Archbishop of Canterbury (AD 960–88). Monks at both Canterbury and Glastonbury claimed to possess his relics and he had shrines in both churches.

St Edburg (Eadburh): Seventh-century Anglo-Saxon princess and nun. A reconstruction of her shrine previously at Bicester Priory survives at Stanton Harcourt (Oxfordshire).

St Edmund: Anglo-Saxon king and martyr (d. AD 869). Killed by Danes who shot him with arrows. His shrine was at Bury St Edmunds Abbey (Suffolk). He is depicted holding an arrow in the 'Wilton Diptych', a portable altarpiece for the private devotion of King Richard II (r. 1377–99), now in the National Gallery, London.

St Edmund of Abingdon (also known as St Edmund Rich, St Edmund of Canterbury): Thirteenth-century Archbishop of Canterbury (d. 1240).

St Edward the Confessor: Anglo-Saxon king (r. 1042–66), with a reconstructed shrine at Westminster Abbey. Often depicted holding a ring symbolising the miraculous story of how he gave a ring to a beggar during the dedication ceremony to a church of St John the Evangelist only to have it returned to him years later by pilgrims; they claimed that the saint had appeared to them in the Holy Land and asked them to return it.

Edward II: King of England from 1307 until he was deposed and murdered in 1327. After his death he was buried at Gloucester Abbey (now Gloucester Cathedral), and when miracles were reported the tomb became a pilgrimage site. Richard II gave royal support for an unsuccessful bid to have Edward canonised in 1395. His tomb survives.

St Eligius (Eloi, Loy): Bishop of Noyon (France) (d. AD 660). Patron saint of farriers. Often depicted shoeing a horse's leg.

St Erasmus: Bishop of Formiae (Italy) and martyr (d. *c.* AD 303). Often depicted being disembowelled with a nautical windlass, a type of winch. Favourite among sailors and weavers. He was also invoked against stomach diseases.

St Erkenwald: Anglo-Saxon Bishop of London (d. AD 693). Founder of St Paul's Cathedral.

St Etheldreda: Anglo-Saxon queen and abbess (d. AD 679). Founder of a double monastery at Ely (Cambridgeshire).

St Eustace: Second-century martyr. Often depicted with a stag with a crucifix between its horns. Wall painting at Canterbury Cathedral.

St Faith (Foy): Third-century virgin martyr. Patron saint of prisoners. Her shrine at the Abbey Church of Saint Foy in Conques, southern France, was a popular stop for pilgrims travelling to Santiago de Compostela. Depicted in wall paintings at Horsham St Faith Priory (Norfolk) and in Westminster Abbey (St Faith Chapel).

Four Doctors of the Church: SS Ambrose, Augustine, Jerome, and Pope Gregory I.

St Francis of Assisi: Founder of the Order of Friars Minor (the Franciscans) (d. 1226). Buried in Assisi (Italy). He is depicted receiving the stigmata, the wounds of Christ, in a wall painting at Slapton (Northamptonshire).

St Frideswide (Frithuswith): Anglo-Saxon princess and abbess (d. AD 735). Patron saint of Oxford. The base of her shrine survives in Christ Church Cathedral, Oxford.

St George: Pseudo-historical martyr. Said to have been a Roman soldier knight and dragon-slayer. Adopted as the patron saint of England by Edward III around 1350.

St Giles: Eighth-century French hermit and abbot, often depicted with a hind, his only companion in the wilderness. When hunters tried to kill the deer with arrows they wounded Giles instead. His cult was widespread across Europe. Patron saint of Edinburgh. Often invoked by cripples. Attributes include a doe or hind at his side, an arrow piercing his hand or side.

St Godric: Hermit at Finchale Priory, County Durham (d. 1170). Never canonised.

St Gregory: Sixth-century pope; one of the 'Four Doctors of the Church'.

St Guthlac: Anglo-Saxon hermit who inspired King Aethelbald of Mercia to build Crowland Abbey (Lincolnshire) (d. AD 714). Scenes from Guthlac's life are carved on the west front of the church. The story of Saint Guthlac is also told pictorially in the *Guthlac Roll*, a set of detailed illustrations of the early thirteenth century, now in the British Library.

St Helena: Mother of the Roman emperor Constantine and discoverer of the 'True Cross' on which Christ had been crucified (d. AD 327–30. By the twelfth century some English commentators said that she was the daughter of King Coel of Colchester.

Henry VI: King of England from 1422 to 1461 and again from 1470 to 1471. After his probable murder miracles were attributed to him. A compilation written around 1500 listed 174 'proven' stories. His cult was encouraged by his nephew Henry VII to promote his own legitimacy to the throne and there were a number of attempts to have him canonised by the pope, all unsuccessful. A money box for offerings at his shrine survives in St George's Chapel, Windsor.

St Hugh of Lincoln: Bishop of Lincoln (d. 1200). Former Carthusian monk and prior of Witham Priory (Somerset). Often depicted with the swan who befriended him. A panel depicting his funeral can be seen in the north rose window at Lincoln Cathedral, probably once part of a larger scheme showing scenes from the saint's life elsewhere in the church, possibly in the north-east transept. The pedestal which held his head shrine survives in the Angel Choir.

Little St Hugh of Lincoln: A young boy whose death in 1255 prompted anti-Semitic blood libels. Never canonised. The base of his shrine survives in the south choir aisle of Lincoln Cathedral.

St James the Great or Elder: One of the original twelve apostles of Christ. His shrine at Santiago de Compostela was one of the major pilgrimage sites in Europe. Patron saint of Spain. Fragments of a once-extensive scheme of wall paintings narrating his life survive at Stoke Orchard (Gloucestershirc).

St Jerome: One of the 'Four Doctors of the Church'. Fourth/fifth century priest and historian who revised

the Old Latin text of the four Gospels from Greek texts (AD 382–84). Author of the 'Vulgate' Bible.

St John the Baptist: Baptised Christ in the River Jordan. Decapitated by King Herod II at the request of Salome, his stepdaughter. Often shown wearing a coat of camel hair and holding the Lamb of God, *Agnus Dei.*

St John of Beverley: Anglo-Saxon Bishop of Hexham and York (d. AD 721). In 1301 King Edward I gave fifty marks towards the building of a new shrine at Beverley Minster (Yorkshire). Edward I visited the Minster in 1296, 1297 and 1300 on his way north to fight the Scots and took the banner of John to aid him. Edward II, Edward III, and Henry IV also used the banner in military campaigns.

St John of Bridlington: Prior of Bridlington Priory (Yorkshire) (d.1379).

St John the Evangelist: Gospel author and evangelist, often depicted with an eagle. Also shown witnessing the crucifixion of Christ or holding a cup from which a serpent emerges, representing a story in which he expelled poison from a drink he was offered by the pagan high priest of Ephesus.

John Schorne: Rector of North Marston (Buckinghamshire) (d. 1313). Never formally canonised. A holy well once thought to have miraculous healing powers for gout and toothache survives in the village. A legendary story says that he cast the devil into a boot. After his death his remains were moved to St George's Chapel, Windsor.

St Joseph of Arimathea: A wealthy follower of Christ who donated his own tomb for the body of Christ following the crucifixion. In later centuries it was claimed that he had brought the Holy Grail (the cup used by Christ at the Last Supper) to England and founded Glastonbury Abbey (Somerset). It is possible that holes in the late fifteenth-century crypt of the abbey once held votive offerings made by pilgrims to the altar of St Joseph.

St Juthwara: Sixth-century virgin martyr from Dorset. Her relics were at Sherborne Abbey, Dorset.

St Katherine of Alexandria: Third-century pseudo-historical virgin martyr. Usually depicted with a wheel, a sword and a book. Wall paintings depicting her life survive at Sporle (Norfolk) and Pickering (Yorkshire). Like many saints she was revered throughout Christian Europe.

St Kenelm: Ninth-century Anglo-Saxon boy king and martyr. His shrine was at Winchcombe Abbey (Gloucestershire).

St Lawrence: Third-century Roman deacon and martyr. Often depicted holding the gridiron on which he was roasted.

St Leonard: Sixth-century French hermit and monk. Founder of Noblac Abbey (Saint-Léonard-de-Noblat). Patron saint of prisoners.

St Lucy: Virgin martyr (d. AD 304). Usually depicted with the knife/sword of her execution. Invoked against blindness.

St Luke: Gospel author and evangelist. Usually depicted with an ox.

St Margaret of Antioch: Pseudo-historical virgin martyr (d. AD 304). Patron saint of childbirth. An extensive scheme of wall paintings depicting her life survives in Battle Church (East Sussex). Panels from schemes in stained glass can be seen at North Tuddenham (Norfolk) and Combs (Suffolk).

St Margaret of Scotland: Anglo-Saxon princess, born in exile in Hungary. After returning to England she fled to Scotland following the Norman Conquest of 1066 and married Malcom III of Scotland around 1070, becoming Scottish queen (d. 1093). Venerated for her piety. In 1250 she was canonised by Pope Innocent IV, and her remains were reinterred in a shrine at Dunfermline Abbey. Her relics were lost after the Scottish Reformation.

St Mark: Gospel author and evangelist. Often depicted with a winged lion.

St Martin of Tours: Fourth-century missionary bishop in France. Often depicted splitting his cloak with a sword to share it with a beggar. His shrine at Tours was a famous stopping point for pilgrims on the road to Santiago de Compostela in Spain. Remains of an eleventh-century cycle of wall paintings depicting his life survive at Wareham (Dorset).

St Mary: The mother of Jesus Christ. Often known as the Blessed Virgin Mary or 'Our Lady'. An extensive scheme of late fifteenth-century wall paintings depicting miracles attributed to her survive in Eton College Chapel (Berkshire).

St Mary Magdalene: According to the gospels she was the first person to encounter the risen Christ after discovering the empty tomb.

St Matthew: Gospel author and evangelist. Often depicted accompanied by a small angel.

St Melangell: Sixth-century Welsh abbess whose courage in rescuing a hare from a hunt persuaded a local prince to found a monastery. Her reconstructed shrine survives at Pennant Melangell, near Llangynog, Powys.

St Michael: One of four archangels (the others being Gabriel, Raphael and Uriel). Often shown as a warrior defeating a dragon or beside the Virgin Mary who intervenes to save the soul of a human whose fate is being weighed in the balance he holds.

St Mungo (Kentigernus): Sixth-century missionary in Scotland. Patron saint of Glasgow.

St Nicholas: Fourth-century Bishop of Myra whose relics were removed to Bari in 1087. Known for many miracles including reviving three boys who had been murdered by a butcher. Patron saint of children.

St Osmund: Anglo-Saxon Bishop of Salisbury (d. 1099). Parts of his late twelfth-century shrine survive in Salisbury Cathedral.

St Oswald of Northumbria: Christian Anglo-Saxon King of Northumbria killed by pagans in AD 642. Interred at Durham Cathedral.

St Oswald of Worcester: Bishop of Worcester (AD 961–72); Archbishop of York (AD 972–92). His shrine was at Worcester Cathedral and he is depicted, together with St Wulfstan, flanking the tomb of King John, now in the choir of the church.

St Patrick: Fifth-century Romano-British Christian missionary and bishop in Ireland. Patron saint of Ireland.

St Paul: Apostle (though not one of the original Twelve), martyred *c.* AD 67. Often depicted as bald with a beard holding a book and a sword, the instrument of his martyrdom.

St Peter: Apostle and first pope, usually depicted with a beard and holding a key.

Richard Caister: Vicar of St Stephen's in Norwich (1402–20), whose tomb attracted pilgrims after his death. A pilgrim badge framed by a scroll shaped like an

'R', and depicting Caister preaching from a pulpit, is in the collection of the Museum of London. His tomb is mentioned in fifteenth-century wills and his grave was visited by Margery Kempe.

St Richard of Chichester: Bishop of Chichester (d. 1253).

Richard Scrope: Archbishop of York executed for treason in 1405. Never canonised. His tomb was in York Minster.

Robert of Knaresborough: Thirteenth-century hermit who lived in a cave at Knaresborough (Yorkshire). Although never canonised he was venerated locally. Seven pre-Reformation stained-glass panels of his life, originally from Dale Abbey, survive at St Matthew's Church in Morley (Derbyshire), and his cave can still be visited.

St Roche (Rock): Fourteenth-century French pilgrim saint invoked for plague-curing powers.

St Ronan: Sixth-century Irish pilgrim and hermit in Brittany.

St Sebastian: Roman martyr saint killed by arrows in AD 287. After an outbreak of plague was reputedly stopped by the erection of an altar in his honour at the Church of Saint Peter in Pavia (Italy), he was thought to offer protection against the plague.

St Sidwell: Sixth-century Anglo-Saxon Christian virgin supposedly killed by reapers at the behest of her wicked stepmother. Often depicted with a scythe. Cult following in Exeter and elsewhere in Devon. Depicted in fifteenth-century stained glass in the chapel of All Souls College, Oxford.

St Sitha (Zita): Italian domestic servant (d. 1272), famed for her piety, chastity and charity. Her body is displayed in the church of S. Frediano in Lucca. Often depicted holding a bunch of keys. Wall painting at Horley (Oxfordshire).

St Stephen: First martyr, stoned to death in Jerusalem in AD 34. Depicted in a wall painting at Black Bourton (Oxfordshire) and in stained glass in York Minster.

St Swithun: Anglo-Saxon Bishop of Winchester (d. AD862). A modern representation of his shrine can be seen in the retrochoir of Winchester Cathedral. His best-known miracle – the restoration of a widow's basket of eggs that had been maliciously broken – is depicted in a wall painting at Corhampton (Hampshire).

St Thomas Becket: English archbishop murdered in Canterbury Cathedral in 1170. Thirteenth-century stained-glass windows in the Trinity Chapel depict miracles at his tomb/shrine.

St Thomas de Cantilupe: English bishop (1218–83). Reconstructed shrine in Hereford Cathedral.

St Urith of Chittlehampton: Eighth-century West-Country virgin murdered by haymakers at the behest of her wicked stepmother. A holy well sprang up where her blood was spilt.

St Ursula: Pseudo-historical Romano-British Christian virgin martyr killed with 11,000 other virgins by pagans in Cologne.

St Walstan of Bawburgh: Anglo-Saxon prince who became a farmer (d. 1016). Popular in Norfolk and Suffolk. Fifteenth-century wall painting at Cavenham, Suffolk.

St Werburgh: Seventh-century Anglo-Saxon princess and abbess. Her reconstructed shrine assembled from surviving fragments in 1888 is in the Lady Chapel at Chester Cathedral, formerly a Benedictine monastery.

St Wilfred: Important Anglo-Saxon bishop (d. AD 709). Both Ripon Cathedral and Canterbury claimed to possess his relics.

St Wilgefortis (Uncumber): Fourteenth-century pseudo-historical virgin martyr who supposedly grew a beard to make herself unattractive to pagan suitors. A statue of her holding a cross can be seen in the Henry VII Chapel of Westminster Abbey.

St William of Norwich: A young boy whose death in 1144 prompted anti-Semitic blood libels. Never canonised.

St William of Rochester (sometimes William of Perth): Pilgrim killed by his adopted son while visiting Rochester Cathedral in 1201. Canonised 1256. His shrine was in the north transept of the cathedral.

St William of York: Archbishop of York (d. 1154, canonised 1227). Life and miracles depicted in stained glass, *c.* 1414, in York Minster. Parts of his shrine exhibited in the Yorkshire Museum.

St Winefride: Seventh-century Welsh Christian virgin who was decapitated by a spurned suitor. A well sprang up where she was beheaded – in Holywell, Flintshire, Wales. In 1138 her relics were taken to Shrewsbury Abbey (Salop) and a shrine built.

St Wite: Female saint, possibly Breton. Also known as St White, Whyte, Witta and Candida. Thirteenth-century shrine at Whitchurch Canonicorum, Dorset.

St Wulfstan: Bishop of Worcester and last Anglo-Saxon bishop in England (d. 1095).

St Zita: *see* **St Sitha**.

FURTHER READING

Attwater, Donald and John, Catherine Rachel. *The Penguin Dictionary of Saints*, 3rd edition. Penguin Books, 1995.

Bagnoli, Martina (ed.) and others. *Treasures of Heaven: Saints, Relics and Devotion in Medieval Europe*. Exhibition catalogue, Yale University Press, 2011.

Brown, Peter. *The Cult of the Saints*. University of Chicago Press, 1981.

Buzwell, Greg. *Saints in Medieval Manuscripts*. The British Library, 2005.

Crook, John. *English Medieval Shrines*. The Boydell Press, 2011. (This book has an excellent bibliography.)

Duffy, Eamon. *The Stripping of the Altars: Traditional Religion in England c. 1400–c. 1580*. Yale University Press, 2005.

Duggan, Anne. *Thomas Becket*. Hodder Education, 2004.

Farmer, David Hugh (ed.). *The Oxford Dictionary of Saints*, 3rd edition. Oxford University Press, 1992.

Finucane, Ronald C. *Miracles and Pilgrims*. Palgrave Macmillan, 1977.

Freeman, Charles. *Holy Bones, Holy Dust: How Relics Shaped the History of Medieval Europe*. Yale University Press, 2011.

Koopmans, Rachel. *Wonderful to Relate: Miracle Stories and Miracle Collecting in High Medieval England*. University of Pennsylvania Press, 2011.

Lewis, Katherine J. *The Cult of St Katherine of Alexandria in Late Medieval England*. The Boydell Press, 2000.

Marks, Richard. *Image and Devotion in Late Medieval England*. Sutton Publishing, 2004. (This book has an excellent bibliography.)

Nilson, Ben. *Cathedral Shrines of Medieval England*. The Boydell Press, 1998.

Norton, Christopher. *St William of York*. York Medieval Press, 2006.

Pinner, Rebecca. *The Cult of St Edmund in Medieval East Anglia*. The Boydell Press, 2015.

Riches, Samantha. *St George: Hero, Martyr and Myth*. Sutton Publishing, 2000.

Rollason, David. *Saints and Relics in Anglo-Saxon England*. Oxford, 1989.

Rosewell, Roger. *Medieval Wall Paintings*, Shire Publications, 2014.

Sumption, Jonathan. *Pilgrimage: An Image of Mediaeval Religion.* Rowman and Littlefield, 1975.

Vincent, Nicholas. *The Holy Blood: King Henry III and the Holy Blood Relic.* Cambridge University Press, 2001.

Voragine, Jacobus de (translated by William Granger Ryan). *The Golden Legend: Readings on the Saints.* Princetown University Press, 2012.

Walsham, Alexandra. *The Reformation of the Landscape: Religion, Identity, & Memory in Early Modern Britain & Ireland.* Oxford University Press, 2011.

Ward, Benedicta. *Miracles and the Medieval Mind: Theory, Record and Event, 1000–1215.* University of Philadelphia Press, 1982.

Webb, Diana. *Pilgrimage in Medieval England.* Hambledon and London, 2000.

Yarrow, Simon. *Saints and their Communities: Miracle Stories in Twelfth-Century England.* Oxford University Press, 2006.

INDEX